IMAGES
of America

LOUDOUN COUNTY
250 YEARS OF TOWNS AND VILLAGES

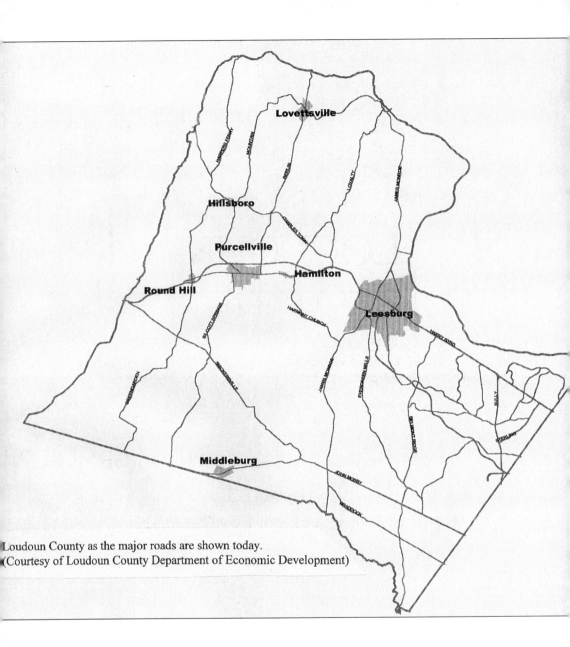

Loudoun County as the major roads are shown today.
(Courtesy of Loudoun County Department of Economic Development)

IMAGES
of America

LOUDOUN COUNTY
250 YEARS OF TOWNS AND VILLAGES

Mary Fishback
and Thomas Balch Library Commission

ARCADIA

Published by Arcadia Publishing,
an imprint of Tempus Publishing, Inc.
2 Cumberland Street
Charleston, SC 29401

Printed in Great Britain.

Library of Congress Catalog Card Number: 99-60802

For all general information contact Arcadia Publishing at:
Telephone 843-853-2070
Fax 843-853-0044
E-Mail arcadia@charleston.net

For customer service and orders:
Toll-Free 1-888-313-BOOK

Visit us on the internet at http://www.arcadiaimages.com

This book was compiled to inspire all those people who endeavor to preserve history and genealogy in one of the best ways possible—photography.

CONTENTS

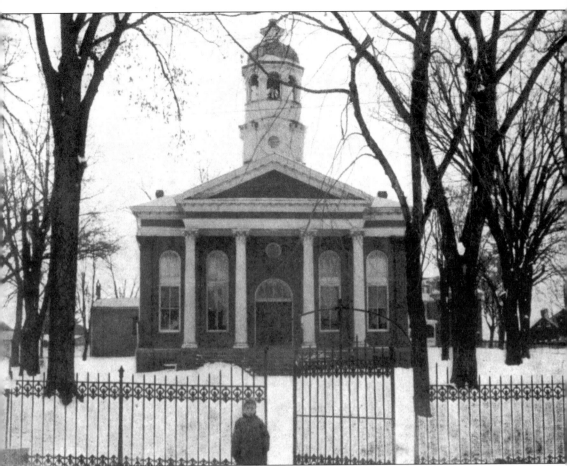

The first courthouse to be built for Loudoun County was ordered in August 1758. The bell for the courthouse was installed in the 1870s. The second courthouse was built on the same property in 1811. The third courthouse to be built on this property was built in the 1890s. This photograph was taken *c.* 1900, before the clock was placed in the tower and the Confederate Monument added.

INTRODUCTION

Loudoun County was formed from Fairfax County in 1757. It was multicultural from its beginnings. African, American Indian, Dutch, English, French, German, Irish, Scottish, and Welsh people all lived in Loudoun County.

This cultural mix led to many diverse architectural styles as well as lifestyles. The purpose of this book is to show, through the eye of the camera, how Loudoun has maintained and blended these cultures for almost 250 years. Loudoun County is comprised of seven incorporated towns and numerous villages and crossroads.

Today, Loudoun is facing new growth and urbanization, yet its people have a deep and abiding interest in keeping their heritage intact for future generations to enjoy.

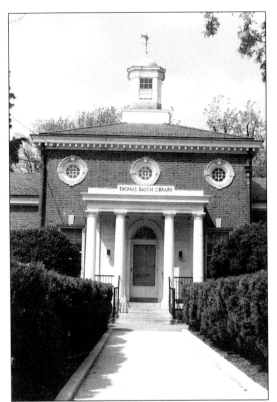

Named in honor of Thomas Balch, the Thomas Balch History and Genealogy Library was built in 1922. Born in Leesburg in 1821, Balch was an international lawyer who orchestrated the Alabama Claims and became known as the "Arbitrator of International Law." Upon his death, his family engaged architect Waddy Wood to plan the library as his memorial. Since 1922, the Balch Library has maintained a historical section. In 1992, the entire building was dedicated to historical and genealogical research, and in 1999, the building will be restored and enlarged by the Town of Leesburg to allow room for Balch to continue to fulfill its functions as a premier historical and genealogical research library in Leesburg, Loudoun County, Virginia.

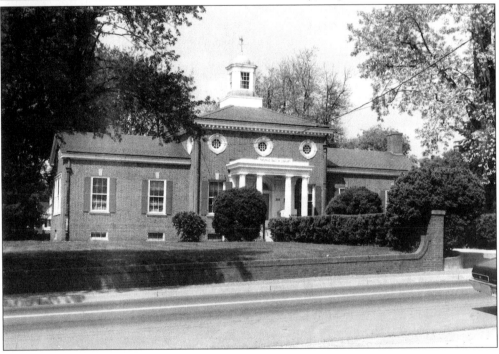

One

THE TOWN OF HAMILTON

The town of Hamilton was established c. 1827 by Charles Bennett Hamilton, with only a corner store and a bank. It took some time for the name "Hamilton" to be in regular use. Until then, the town was referred to as "Harmony," a name meaning "at peace with God and nature." Harmony's roots date back as far as 1768, with the Tavenner and Roach families using that name for the area.

Hamilton has a strong Methodist heritage. Harmony Methodist Church was built in 1833. Richard and Nancy Tavenner deeded 1.5 acres for the church's use. The building has gone through several remodelings and additions since that time. There is a cemetery connected to this church, and near that cemetery is another cemetery that was deeded to Mount Zion, an African-American church in Hamilton.

Mount Zion United Methodist Church was established by African Americans in 1881. Its original trustees were Lafayette Mann, George Lee, Alfred Grigsby, Lewis Hill, and Charles Taylor. The church remains a vital part of the community.

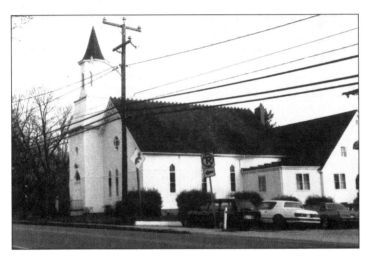

The Baptist heritage is also strong in Hamilton. This church was built in 1889. It had classrooms and Sunday school rooms added in 1950. The Fellowship Hall was added in 1968.

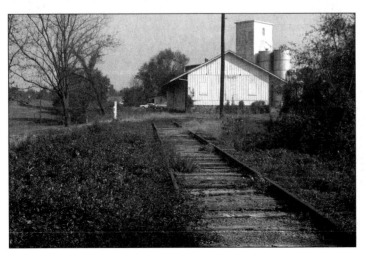

Hamilton was like many towns in the 1880s and 1890s, and the Washington and Old Dominion Railroad played a large part in the social and economic climate of the town. This photo by W.E. Barrett was taken in 1968, looking east toward Leesburg.

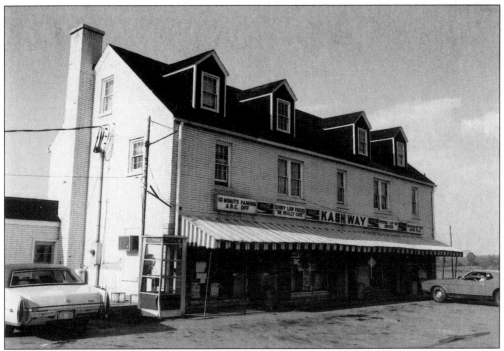

Old Route 7 runs through the town of Hamilton. A familiar sight to people in the 1960s and 1970s was the Kashway IGA. At that time, Roger Fields operated the store. Since then, the building has housed several restaurants. The Beautiful South restaurant is located there today.

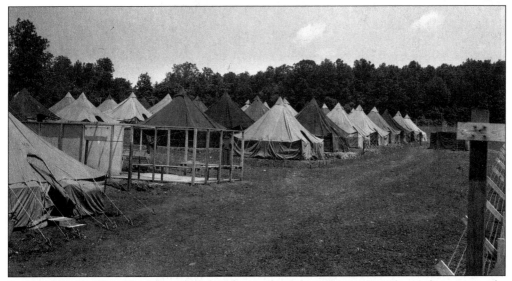

During World War II, there was a German prisoner-of-war camp located just outside of Hamilton, near Woodburn Road. Little is known about the camp. It existed for only a short while.

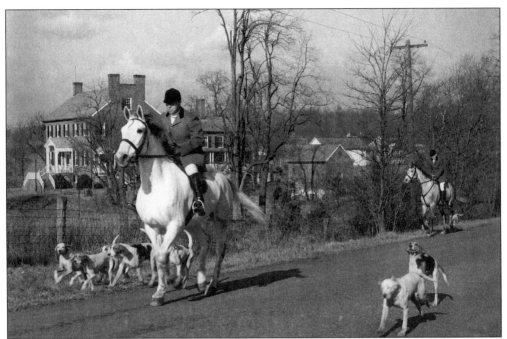

Hamilton has always been a great place for Loudouners to fox hunt. Hunton Atwell, master of hounds, is pictured in the lead; he is followed by Dr. Joseph Rogers, an avid huntsman.

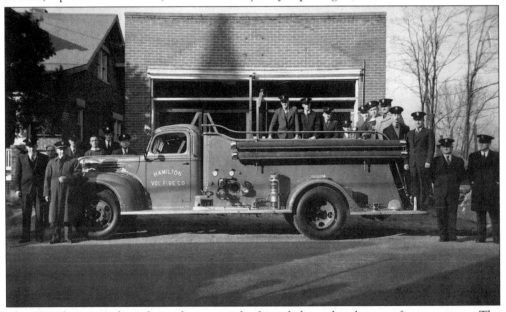

The Hamilton area has always been proud of its dedicated volunteer fire company. The members of the Hamilton Volunteer Fire Company between 1943 and 1950 were R.B. Trussell, Charles H. Menefee, Kenneth Rollison, Harry H. Trussell, A. Richmond Ely, Marvin (Sleepy) Myers, Hugh Tillett, C. Maloy Fishback, W.D. Clark, Lee White, Lewis Putman, Ronald S. Clark, Leonard A. Tillett, Robert Carter, William H. Milbourn, Worth Blevins, G.G. Titus, Walter R. Duncan, Thomas Payne, Adrian Tavenner, Howard Mossburg, and Earl Wine. This 1946 photo shows some of the men listed above.

Two
THE TOWN OF HILLSBORO

Route 9 runs directly through Hillsboro. The Short Hill Mountains crest low on either side of the town.
The gap at Short Hill was used as early as 1736 by settlers as a main passageway to Vestal Gap and on
to the Blue Ridge, Alexandria, and Winchester.

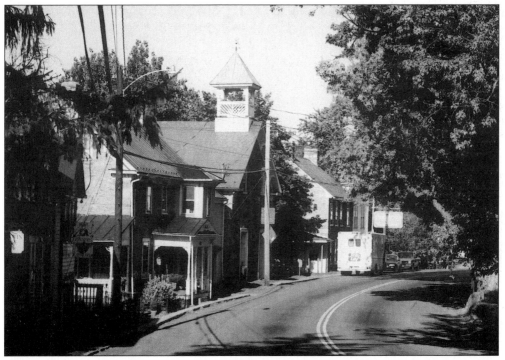

As can be seen in this photograph of the town's main street, the houses were built close to the
road.

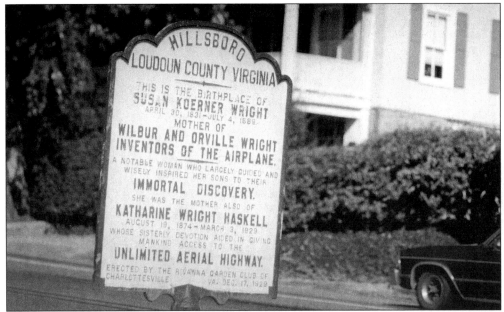

Hillsboro has several claims to fame. This state marker tells travelers that the mother of the Wright brothers, Susan Koerner, was born here. It also notes other interesting historical facts.

The log addition at the rear of the main house (built c. 1910) was acquired by the Boxleys, who came from the area between Hillsboro and Lovettsville known as the Arnolds Store area. County records established that the log addition was in existence in 1793, but physical evidence suggests the cabin is considerably older. Most of the original construction was held together by wooden pegs; there were 14 hand-forged iron rafter spikes used as well. The cabin was constructed of walnut sills, chestnut logs, wild cherry rafters, chestnut flooring, and poplar paneling. Mr. Boxley alone dismantled, moved, and reassembled the cabin in the summer of 1984 in Purcellville.

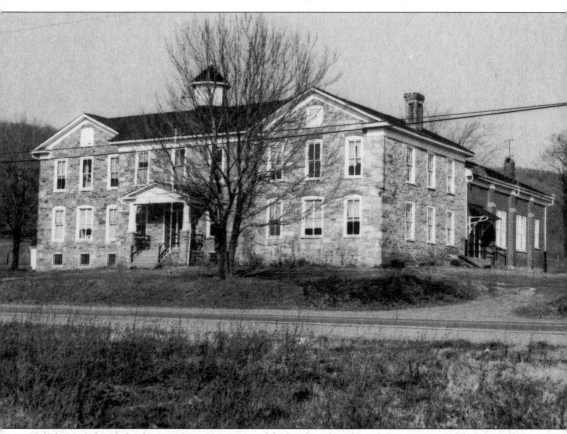

Hillsboro School, built *c*. 1880, is a very visible landmark. The west wing was added in 1917, and an auditorium was constructed in 1928. It was condemned in the 1970s. Now re-activated as the Hillsboro Community Center, it offers various programs and "pot luck" suppers for all to enjoy. This photo was taken in 1971.

Pictured in this 1957 view is one of the main churches in the Methodist church circuit. Deeded to the congregation in 1830 by Michael and Christina Arnold, the church still bears the name Arnold Grove. There is an old cemetery in back.

Three

THE TOWN OF LEESBURG

Leesburg was known as Georgetown in 1757–58. It was part of a grant from the sixth Lord Fairfax to Francis Awbrey in 1730. About 1755, Nicholas Minor bought and laid out the town of Georgetown. In 1759, the area was renamed for the prominent Lee family. Leesburg has been the county seat since 1757 and has played host to local politicians, presidents, and foreign dignitaries from all over the world for the last 250 years. It continues to do so today.

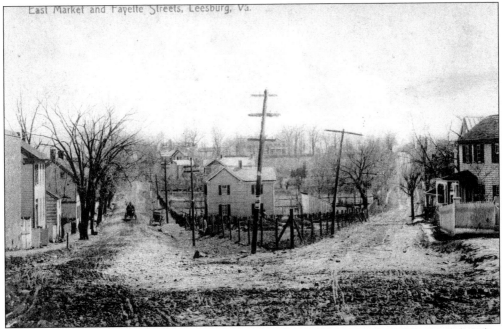

This postcard, produced between 1890 and 1900, shows the east view of Route 7 (Market Street) and Edwards Ferry Road.

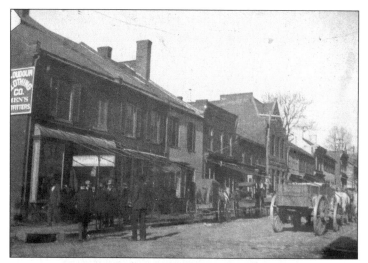

This picture was taken by William C. Whitmore Sr. *c.* 1900. It depicts Route 15 (King Street) looking north toward Frederick, Maryland. The county courthouse (off picture) is on the left.

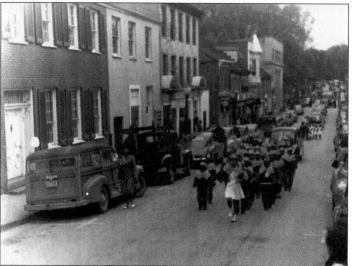

Parades and pageants have always been a part of the Leesburg scene. This 1940s photo shows cars parked on both sides of Route 15, the main north-south travel route in Leesburg. In the 1960s, this traffic pattern ceased. Now there is only parking on the southbound side of the street. This image is an inverted image of the street scene.

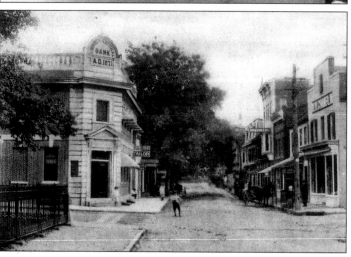

In this postcard of King Street (Route 15) looking south toward Warrenton is a view of Loudoun National Bank (left), which remained in business until the 1990s. In the early years of this century, a third story was added to the bank. Market Street (Route 7) runs east to west. This intersection has been a major crossroad since Leesburg was founded in 1757.

This photo depicts the reunion of ex-Confederates in Leesburg c. 1895.

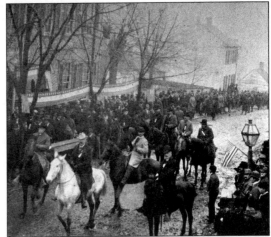

The Clerks Office was built c. 1800. In 1990, it was moved to new quarters on the north side of the courthouse lot. Today, a new clerk's office is being remodeled and expanded. The clerk of court is responsible for keeping all state-mandated records. Loudoun County has kept all of its original records intact since 1757. Neither the courthouse nor the clerk's office suffered the ravages of the Civil War. George K. Fox was the clerk in the 1860s and took the Loudoun County court records to Campbell County, Virginia. They were returned after the war ended.

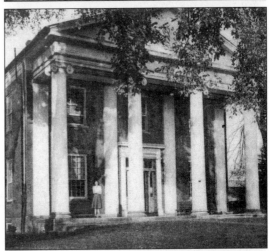

This monument to Loudoun County's Confederate soldiers was erected in 1908. It reads, "In memory of the Confederate soldiers of Loudoun County, Virginia. Erected May 28, 1908." It was created by sculptor William Sevier, who did work with the Gettysburg Battlefield. Henry Jefferson Houpt was responsible for building the concrete base of this monument. A native of Pennsylvania, he was one of the first men to use concrete in the building of bridges in Loudoun County.

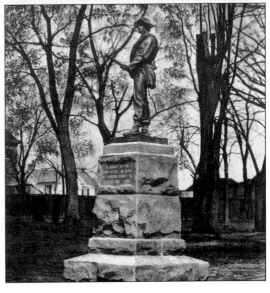

The Grove, located near Leesburg, was owned in 1846 by Thomas L. Ellzey. Comprised of over 700 acres of land, it remained in the Ellzey family until 1920. The house was vacant for years. In the 1960s, the Virginia Highway Department overtook the land to build a highway. This photo was taken prior to its demolition.

Carlheim, built c. 1865 by Charles Paxton of New York, was modeled after an ancient German castle. Joe Norris was contracted to build the home. Initially called Carlheim, it was later renamed Paxton Home and served as a school and an orphans' home. Today, Paxton Home is a child development center located off Route 15 North. (Photo courtesy of Balch Library.)

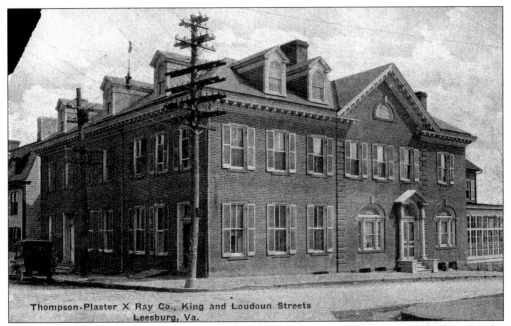

The home of the Bengston family for a few years, this building became a private residence in the 1860s. In this *c.* 1901 postcard, it was being used to house the Thompson-Plaster X-ray Company. Today, it is an antique shop. (Postcard courtesy of Emory Plaster.)

The Odd Fellows Hall was built in the mid-to-late 1700s. Its original use is unknown, but for many years it served as a home for the Loudoun County Independent Order of the Odd Fellows. Today it houses the Loudoun Museum, one of the premier repositories for Loudoun County memorabilia.

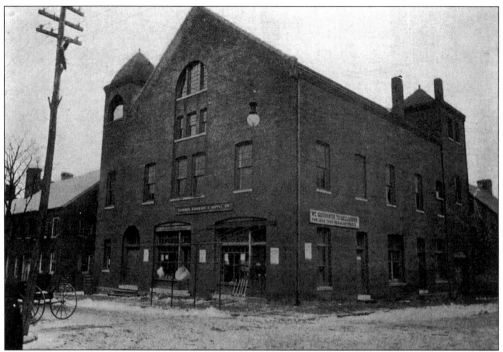

The Leesburg Opera House was located on the corner of King and Loudoun Streets. Built in 1870 by the Norris Brothers Firm, it served as an opera house and town hall and seated over 450 people. According to newspapers, the infamous Belle Boyd came to Leesburg and gave a speech about her escapades in the Civil War. The building was destroyed to make room for a department store. This photo was taken *c.* 1901.

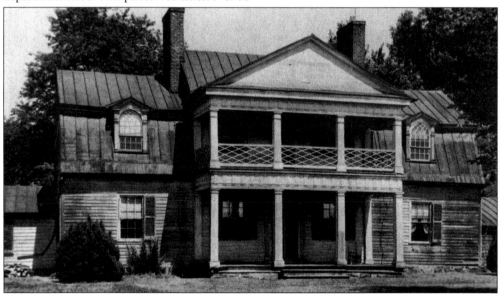

Exeter was built *c.* 1799 for Dr. Wilson Cary Seldon on land he inherited from his first wife, Mary Mason Seldon. She was a niece of George Mason of Gunston Hall. In 1980, a fire destroyed this old mansion. The land is now part of a large subdivision that still bears the name Exeter. (Photo courtesy of the John Lewis File at Balch Library.)

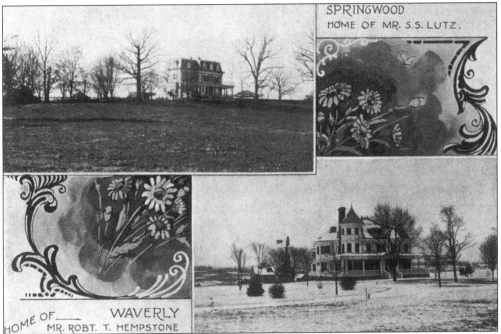

Springwood (top) has an interesting history. It was built *c.* 1840 on property previously owned by a cousin of George Washington, Burgess Ball. In 1866, Mr. and Mrs. G.W. Ball used the manor house as a boarding school for ladies. In this century, Mrs. Porter ran a school for mentally challenged students. Today, the old Ball cemetery remains intact. Springwood (now Piedmont) serves as a psychiatric treatment facility. Waverly (bottom) was part of a large farm in 1900. It has since been remodeled and now serves as part of Waverly Park offices.

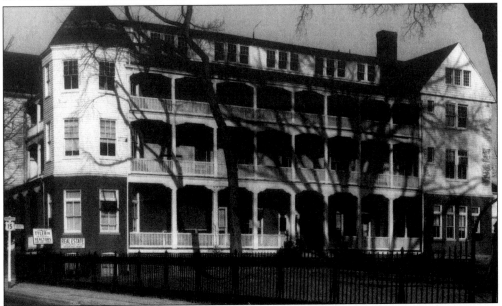

The Leesburg Inn hosted travelers from all over the world. Better known as the Old Hotel, it was built in 1888 by the Norris Brothers Construction Firm. The Old Hotel was used as office space for many years. It was torn down to make way for county government offices in the 1970s.

Greenwood Farm was built between 1780 and 1800. It was owned by the Reverend George Adie, the minister of St. James Episcopal Church, from 1832 to 1854. It was later part of the Rust estate. This house is currently the main office for Ida Lee Park on land donated by the Rust family. (Photo courtesy of the John Lewis File at Balch Library.)

The old St. James Episcopal Church stood on North Church Street, adjacent to the present cemetery grounds and the county jail. The following excerpt, a caption from the *Loudoun Times Mirror*, is from Miss Lizzie Worsley's diary: "Sunday, November 21, 1897, the Rev. Edwin S. Hinks preached for the last time in 'old St. James' church. While no notice had been given to this effect, many knew efforts were being made to have the 'new church' ready for service on the following Thursday, Thanksgiving Day, and that the Rector wished to continue the services there if possible, consequently many thought and felt this to be the last service. Though the majority desired to move, and knew for every reason it would be better, still, there was an unspoken sadness in many hearts, when the joys and sorrows of bygone days clustered round 'the last time,' and faces and forms came before us which we have loved long since and lost awhile."

This postcard, borrowed from Emory Plaster, shows an interior view of the old St. James Episcopal Church as it appeared during the Christmas of 1895.

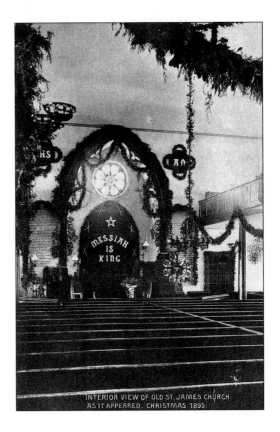

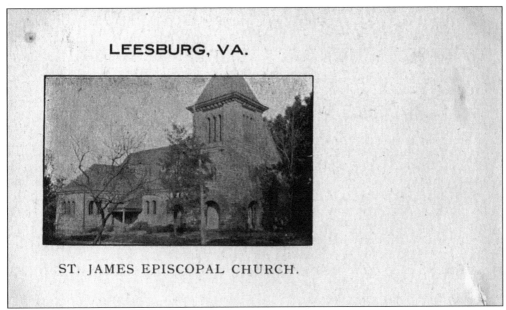

This c. 1910 postcard shows the new St. James Episcopal Church shortly after it was built.

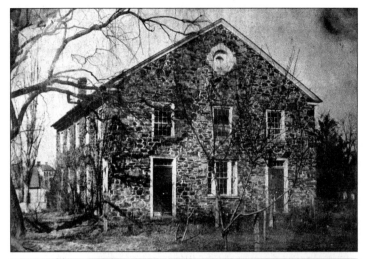

This copy of an 1892 photo shows the Old Stone Church. The church was torn down in 1902, and all that remains is a very old cemetery.

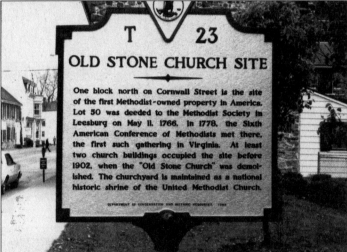

This state highway marker tells the fate of the Old Stone Methodist Church.

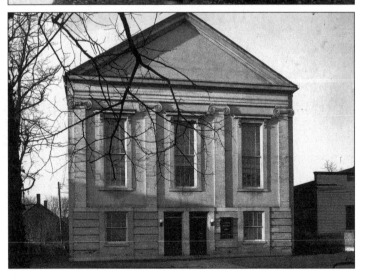

The current Methodist church was built in 1852. During the Civil War, it was used as a hospital for wounded soldiers.

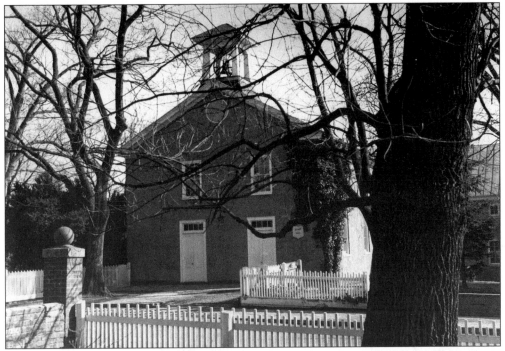

Completed in 1804, the Presbyterian church is the oldest church building still in use in Loudoun County. It has had only minor changes since that time and was beautifully reconditioned a few years ago. A cemetery dating back to the 1730s surrounds the church.

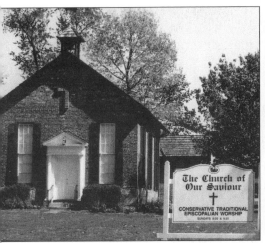 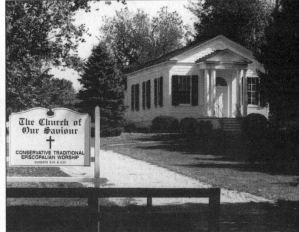

Oatlands Church (left), better known as Church of Our Saviour, was established in 1878. It is located on land that once belonged to Oatlands Plantation. The white building (right) is the Parish Hall. Reverend Elijah White is the current minister of the church.

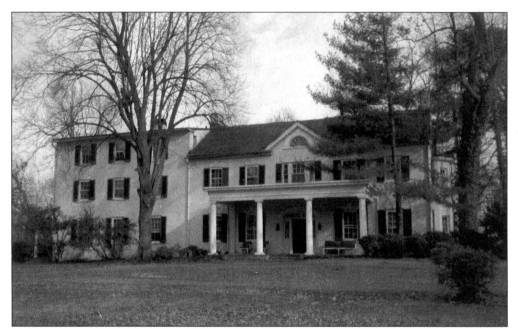

Situated on 8 acres of land, Dodona Manor is one of the older homes in Loudoun County. Owned in 1826 by John Drish, son of Wilson J. Drish, the manor has served as home to many famous people, including Burgess Ball; Zebulon Pike of Pike's Peak fame; and Northcutt Ealey, attorney to Herbert Hoover. In the 1940s, General George C. Marshall owned the house. To honor him, a foundation was established to preserve and restore Dodona Manor. Burr Powell Harrison, an aide to Gen. George Marshall, was instrumental in establishing the George C. Marshall Foundation.

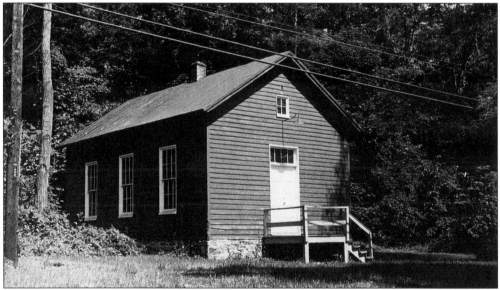

Mountain Gap School, a one-room school, was built about 1880 on land purchased from George Carter in 1827. The school was in operation for over 70 years, and it closed its doors in 1953. The school is across from Oatlands Plantation. (Photo courtesy of John Lewis File at Balch Library.)

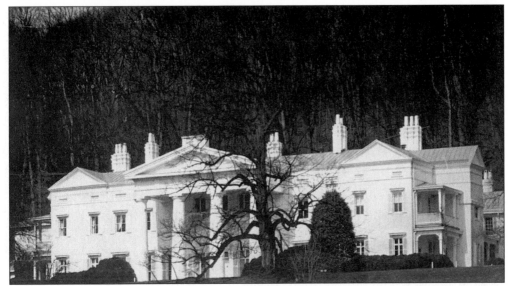

Morven Park, built in 1781, has served as home to two governors, Westmoreland Davis of Virginia and Thomas Swann of Maryland. Governor Westmoreland Davis was the author and publisher of the *Southern Planter* magazine, which was the predecessor of *Southern Living* magazine. Davis was an avid huntsman and equestrian. After his death, the Westmoreland Davis Foundation was established to maintain the property. Today, the manor house and carriage house are open to visitors. Also located on the property is the DuPont Scott Medical Equine Center. (Postcard courtesy of Morven Park.)

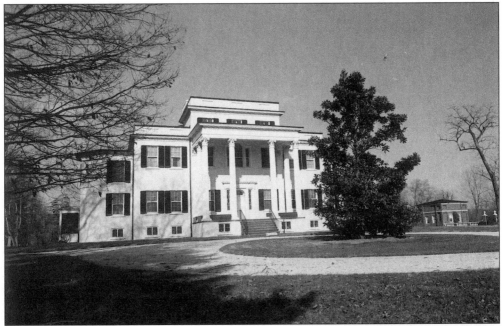

Oatlands is another large estate in Loudoun County. It was designed and built by George Carter, the grandson of Robert Carter. It has had no structural changes since its completion in 1800, but the rose gardens are being restored. Oatlands is part of the National Historic Trust Properties and is open to the public. (Photo courtesy of the John Lewis File at Balch Library.)

Oak Hill remains one of the largest estates in Loudoun County. Located near Leesburg, Virginia, it was the home of President James Monroe. It was in the dining room at Oak Hill that Monroe drafted his famous doctrine. Oak Hill was designed by Thomas Jefferson and its construction was supervised by James Hoban, the builder of the White House in Washington, D.C. Monroe moved into the house in 1832. Today, the home is privately owned. The grounds and house are open to the public on a limited basis and for special occasions only. The gardens are well maintained and beautiful. The bottom photo shows the side/rear entrance to the estate. (Photo courtesy of the John Lewis File at Balch Library.)

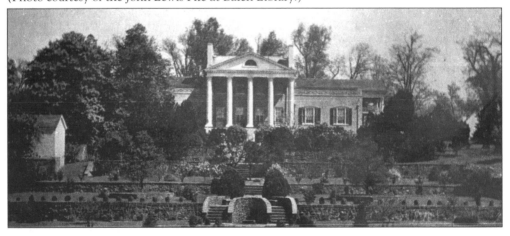

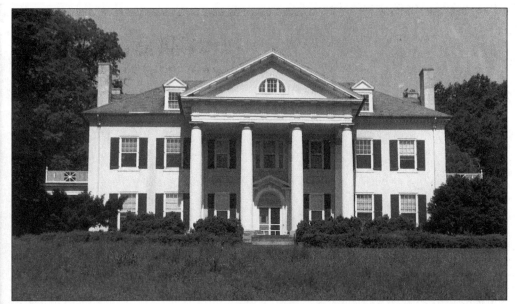

Selma Plantation was originally built in 1800 by General Armisted Thomson Mason. It was part of the original 10,000 acres owned by Mrs. Ann Thomson Mason of Gunston Hall. General Mason, a U.S. senator from Virginia, was mortally wounded at the famous duel with his cousin, John Thomson Mason McCarty. The duel took place in Bladensburg, Maryland. In February 1819, Selma was purchased by descendants of Governor Swann, who owned Morven Park. The property once belonged to J.M. Beverly, the wife of Senator Harry Byrd. It then passed to Elijah B. White. In 1896, the house was severely damaged by fire. The White family had the house handsomely restored.

Locust Grove, now called Liberty Hall, dates from c. 1812 (the date of the "new" house). The land was originally owned by Isaac Van Deventer of Somerset County, New Jersey. Joseph Van Devanter, son of Isaac, was the first one to live in the new house at Locust Grove. He was a lieutenant in the War of 1812. During the Civil War, the house was used as both a refuge for young ladies and a boarding school. Mosby's men were taken by surprise and killed in or near the house. Its name was changed to Liberty Hall shortly after. (Photo courtesy of the John Lewis File at Balch Library.)

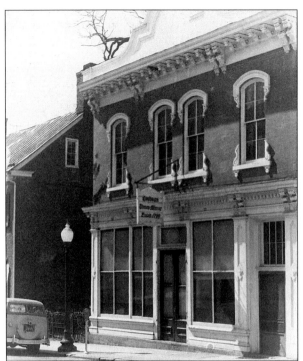

The old *Loudoun Times-Mirror* newspaper office was housed in this building in the 1950s and 1960s on North King Street. Later, the *Washington Post* used this building for a satellite office. The wonderful architecture of the building remains today.

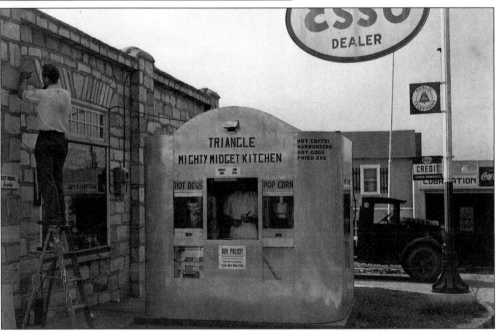

The Mighty Midget Kitchen was a major eatery in Leesburg from 1946 until about 1989. It was owned and operated by Herman and Katherine Costello. In 1959, the original Mighty Midget was destroyed by a youth who crashed into the metal building with his automobile. The destroyed building was pre-fabricated from World War II airplane metal. The repairs on a new kitchen were also made of recycled metal and material. The Mighty Midget remains open for limited business near the downtown Market Station in Leesburg.

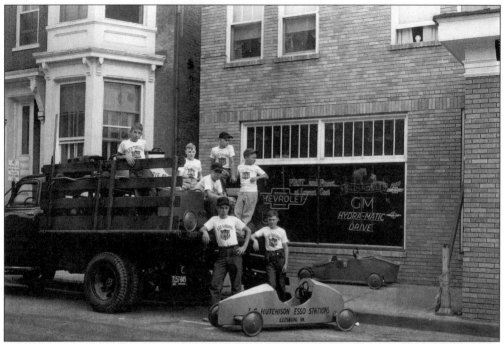

In the 1950s and 1960s, soap-box derby racing was a great pastime for children. Derby racing was sponsored by many local businesses. Hutchison's Esso sponsored this particular car.

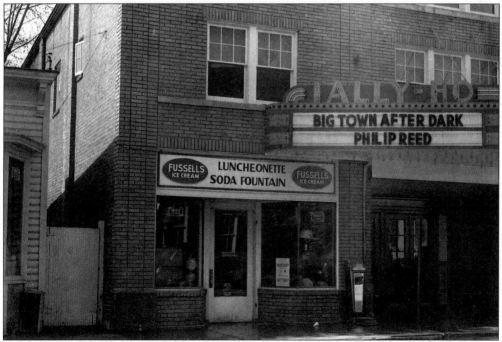

The Pitts-Tally-Ho Theatre was built in the 1930s. It provided entertainment for all ages and featured newsreels and cartoons. The soda fountain next door was a popular hang-out after the movies. The Tally-Ho continued to show movies until the 1990s. The Regal Theatre purchased the building recently, and it is still a cinema. The building to the left was demolished.

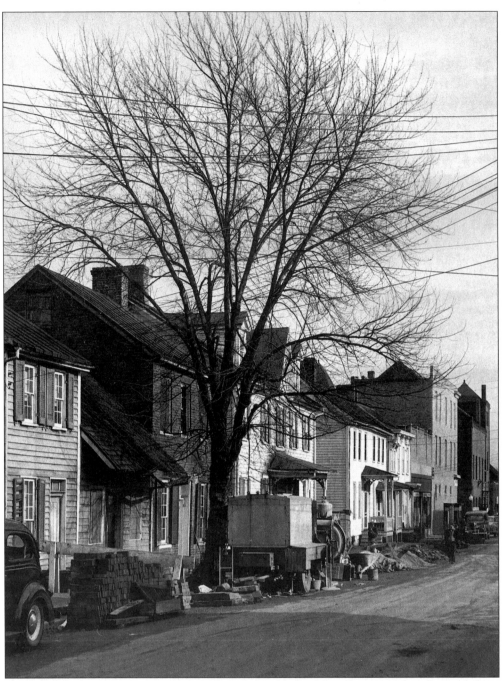

Leesburg has always had a love-hate relationship with its sidewalks. The sidewalks have been made of dirt, concrete, brick, concrete again, and now are constructed once again with brick. This c. 1935 photo shows Loudoun Street getting new brick sidewalks. Notice the old Opera House (top left). (Photo courtesy of Winslow Williams.)

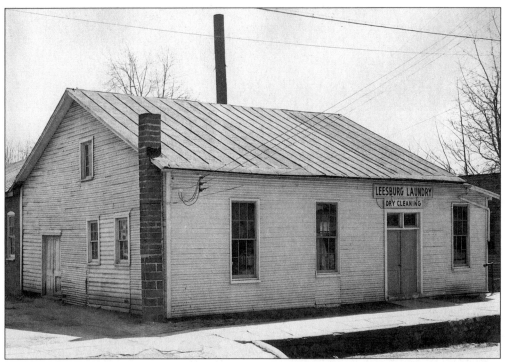

According to research by Winslow Williams, this photo is a view of the Leesburg Laundry before the present brick building was erected. It was built by Coleman Gore. Terry Hirst took it over for a lumber yard. It served as an antique shop for a while, located on South King Street near the Town Branch, on the east side of Route 15.

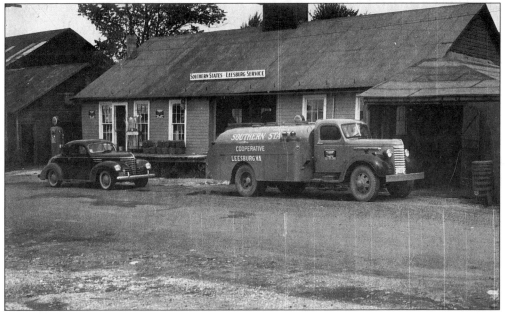

Southern States Cooperative has long been of service to Loudoun County. The Leesburg office of Southern States was located on Harrison Street, across from Market Station. (Photo courtesy of Winslow Williams.)

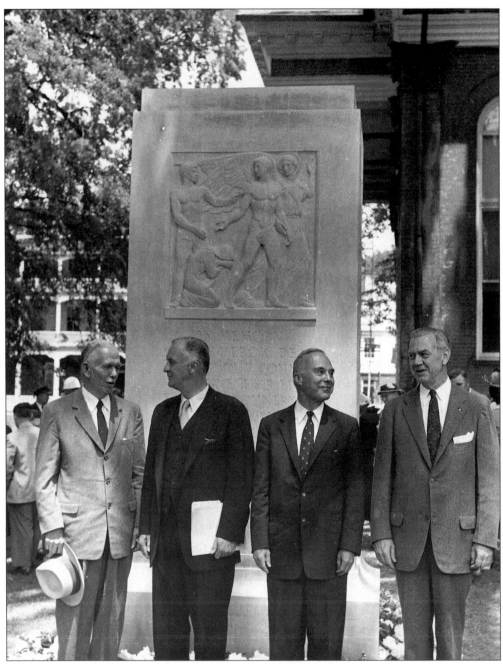

In 1956, the Memorial Day dedication of the World War II Memorial was held at the Loudoun County Courthouse. Those in attendance include the following, shown here from left to right: General George C. Marshall, Virginia governor Colgate Darden, sculptor and Leesburg mayor Walter Hancock, and E.B. White. General George C. Marshall's residence, Dodona Manor, is located several blocks east of the courthouse.

Old Godfrey Field is located just outside of Leesburg. Legend has it that the first plane landed in that field when it was a cow pasture in 1918. The property was known as the George Farm. In 1952, radio commentator and international entertainer Arthur Godfrey bought the George Farm and used it as his airport. Later that year, he suggested the name Leesburg Municipal Airport. The airport is presently owned by the Town of Leesburg and is called the Leesburg Municipal Airport. To many old timers, it's still called Godfrey Field.

Shown here is the law office of Herb Pearson. According to Miss Virginia Lewis, there was a secret room in the office that was used to hide Northern soldiers during the War Between the States.

The Daniel Triplett House, located on Market Street, is one of the older homes in Leesburg. It is also called the Kline House.

This was the first African-American school in Leesburg.

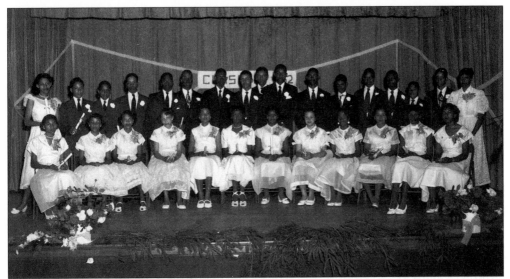

The first African-American public high school in Leesburg was erected in the 1920s. In 1941, it was replaced by a new brick building known as Douglass High School (named for Frederick Douglass). Douglass High graduated its first class that same year. Pictured here are the graduates of the 1952 class: Estelle Helen Anderson, James Patrick Anderson, Vivian Fostine Ashton, Robbie Juanita Berry, Bertha Josephine Coates, Kenneth Lee Ferrell, Walter Wesley Gaskins, Jacqueline Christine Grayson, Franklin Wade Jackson, Gilbert Johnson, Robert Earl Jones, Susie Grooms, Gwendolyn Marie Lincoln, Francis Virginia Morris, Viola Helen Smith, Ernestine Thomas, Janet Ida Thomas, Betty Mae Thornton, Helen Gertrude Thornton, James Rudolph Thornton, Yvonne Thornton, Edith Mae Trammell, Gertrude Ollie Winston, and Ophelia Russ.

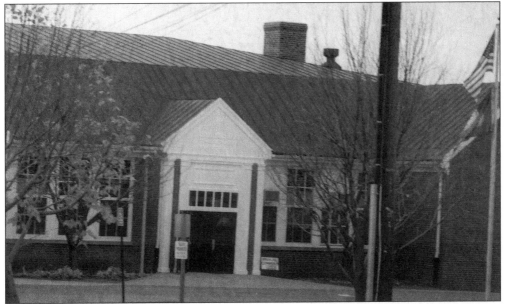

Douglass High School closed in 1968 and became an alternative school, and later, a community center. Today, Douglass Community Center and Annex houses classes for challenged students and has a youth center featuring in-line skating, a large gym, and a recreational park.

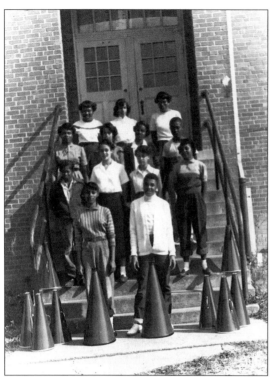

Pictured are Douglass High School cheerleaders, c. 1940.

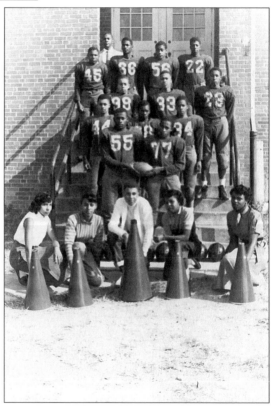

This is a view of the Douglass High School football team and cheerleading squad.

Four
THE TOWN OF
LOVETTSVILLE

In the 1730s, a land grant was established for what is now known as Lovettsville. The grant consisted of 2,250 acres on Dutchman's Creek. At that time, German settlers were inhabiting much of Loudoun County. In 1757, the Germans honored Daniel Lovett, a Scotsman who served as a land speculator for the area, by naming the town after him.

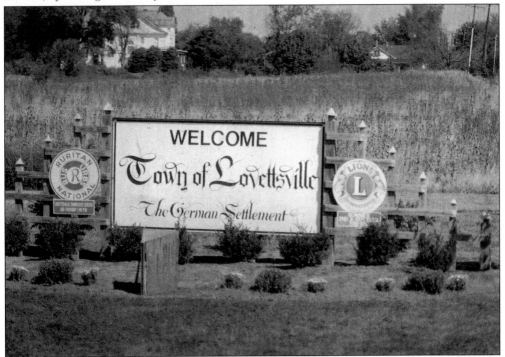

This sign, located north on Route 287, greets visitors entering Lovettsville.

The Germans that settled in Lovettsville were religious and came to this area with their faith well established. The churches are a focal point for Lovettsville's history. St. James Reformed Church started as a log meeting house in 1775. It was later replaced by a newer brick building, which was demolished in 1901. It was rebuilt as the St. James United Church of Christ.

The Lovettsville New Jerusalem Lutheran Church was organized in 1765. It has had 28 ministers since it started, including J.S. Schwerdfeger, J.A. Krug, J.G. Graeber, F.W. Jasinsky, D.F. Schaeffer, J.M. Sackman, A. Reck, M. Blumenthal, D.J. Hauer, P. Willard, C. Startzman, W. Jenkins, J.B. Anthony, K.J. Richardson, A.J. Buhrman, P.H. Miller, D. Schindler, M.E. McLinn, L.H. Waring, A. Richard, J.E. Mauer, F.W. Myer, R.S. Poffenbarger, W.E. Saltzgiver, A.F. Tobler, W.A. Janson, W.A. Wade, W.J. Yingling, and M.W. Kretsinger. The original church was a log structure, and the brick building was built in 1802, only to be destroyed by a snow storm in 1839. The church was re-built and gutted by fire in 1868. Again, the church was re-built. The bell tower was added in 1904, and a new wing was added in 1964. A cemetery that dates to the mid-1700s is to the west and rear of the church. The German settlers kept well-organized genealogical and historical records.

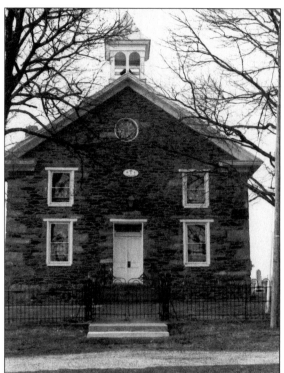

The Mount Olivet United Methodist Church is located on Route 690 near Lovettsville. Built c. 1880, it was made of native stone from surrounding farms and has a large cemetery in the back.

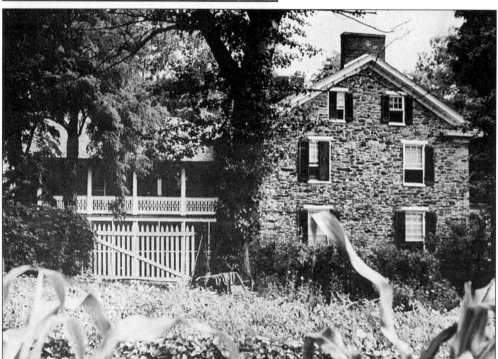

The Samuel W. George Mill is a post-Civil War structure. It was built about 1869 or 1870. According to Bob Wire, an owner of George's Mill, the Roller family built the foundation and the Wright family built the wooden structure.

44

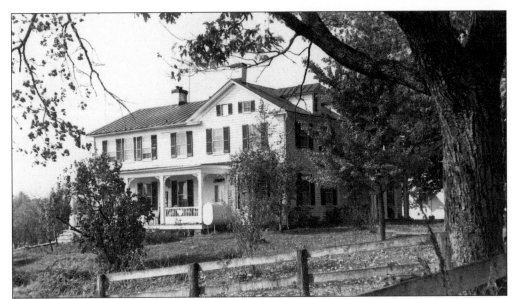

Brookdale is located in Lovettsville. In the will of Peter Compher, dated 1856, he left the property to his daughter Catherine, who married Jacob Householder. The Householders sold the property to John Souder and his wife, Mary. Widowed in 1876, Mary M. Souder sold the property to Mary C. Rodeffer. The Rodeffers still own the partially log-constructed home. (Photo courtesy of the John Lewis File at Balch Library.)

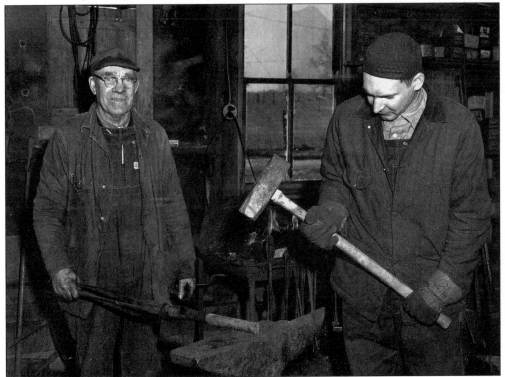

This blacksmith shop was in operation until the 1960s. William Moore is shown here with an assistant in 1954. (Photo courtesy of Winslow Williams.)

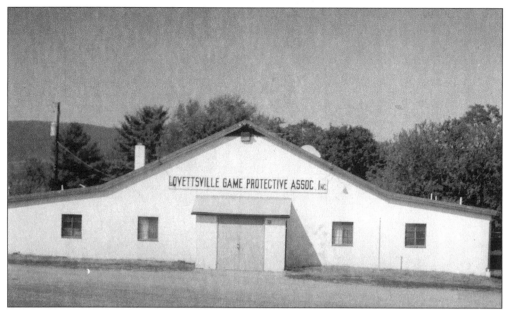

The Lovettsville Game Protective Association Inc. was started in the 1950s when a group of Lovettsville citizens became concerned about the diminishing native wildlife. The "Game Club" has since become a community organization. It is available for many civic functions, including dances, picnics, fireworks, and carnivals, and is famous for its annual German-style Octoberfest.

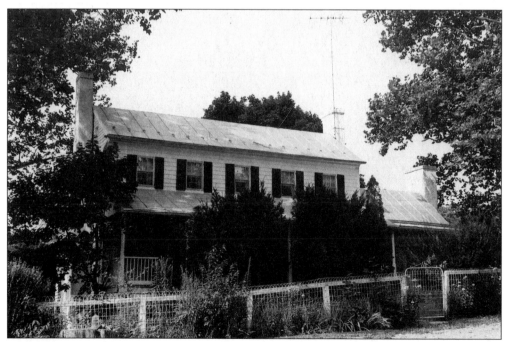

Glendale Farm is located near Lovettsville. The property was leased and later purchased by Jacob Slater from the Earl of Tankerville in 1789. It remained in the Slater family until 1949. (Photo courtesy of the John Lewis File at Balch Library.)

Five

THE TOWN OF MIDDLEBURG

Middleburg is well known for being the "Hunt Country" area of Loudoun. It was owned in 1731 by Rawleigh Chinn. In 1763, Leven Powell purchased much of the land where present-day Middleburg is located. The Virginia Assembly established the town in 1787.

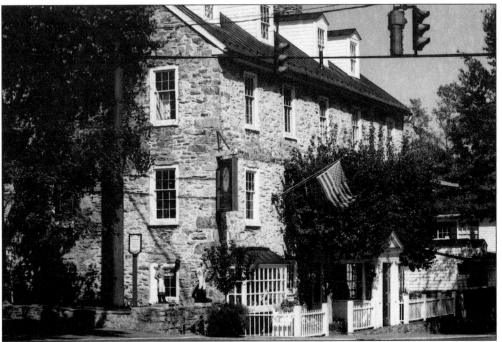

Established in 1928, the Red Fox Inn was originally Chinn's Ordinary. Its fieldstone walls were 30 inches thick. The Red Fox Tavern is a favorite restaurant of the Hunt Country crowd and tourists alike.

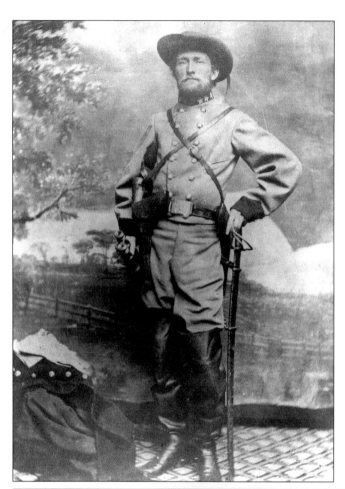

Col. John Singleton Mosby, the great guerrilla war fighter for the Confederacy, often rode through Middleburg and out to Atoka on his raids. This Balch Library photo depicts Mosby with a sabre, which he rarely wore or carried into battle.

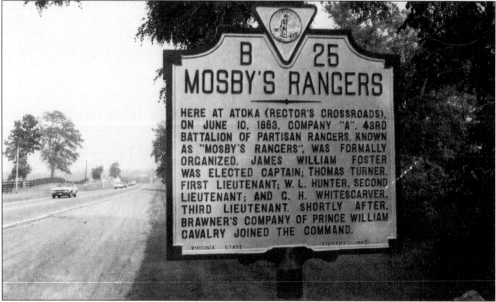

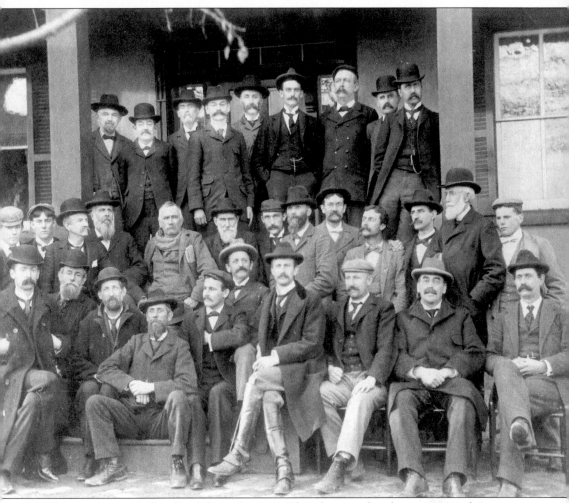

Middleburg was proud of its Confederate heritage. This photograph, taken *c.* 1890 in downtown Middleburg, shows the Confederate veterans and their sons. This photograph was given to Balch Library by Miss Virginia Williams, whose father, Ashby Williams, is pictured. The veterans, from left to right, are as follows: John Doyle, Dr. Edw. Powell, Wm. Yates, Edw. Pontz, Dr. Randy Smith, Earl Yates, Jos. Martin, Rev. S.V. Hilderbrant, James Bennett, Harry Priest, Noel Lynn, W.H. Adams, Dr. W.J. Luck, John H. Smith, J.S. Welsh, John Roche, S.H. Pearson, J.W. Cochran, J.W. Mitchell, Chas. Downs, Rev. W.F. Dunaway, Fenton Priest, Dan Smith, J.H. Priest, Sam Duffey, W.H. Hoskinson, Roszier Luck, Joseph Davis, S. Preston Luck, W.R. Keeler, E.L. Brown, and Ashby Williams.

The Asbury Methodist Church is Middleburg's oldest historic church, dating to 1829. The slavery issue divided the congregation during the Civil War years, and the church was left idle, to be used variously as temporary barracks, a hospital, and a storehouse for grain. In 1864, the church was turned over to the Black Methodist Episcopal congregation, who did extensive repair and restoration to the building. It became the first African-American church in Middleburg.

Shiloh Baptist Church was built in 1913 on the site of an earlier African-American church. Today, its congregation thrives, and additions have been made to the original structure.

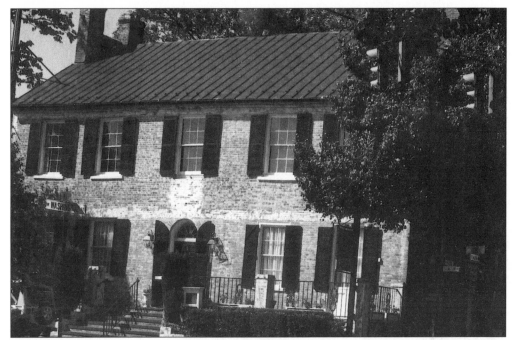

The Windsor House, now a restaurant and inn, was built about 1824. It has served as a private home and as the Colonial Inn (until recent years). This photo shows where a porch was once attached to the front of the house.

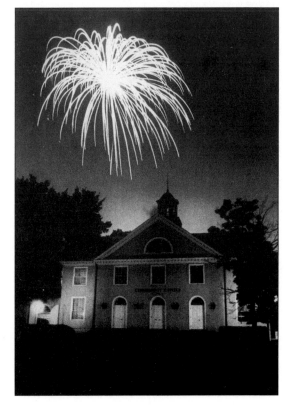

One of the major components of Middleburg life is the Middleburg Community Center, shown here with fireworks. The Community Center has been a library, a bowling alley, and has offered swimming and recreation to the town for over 40 years. (Photo courtesy of Howard Allen Studios.)

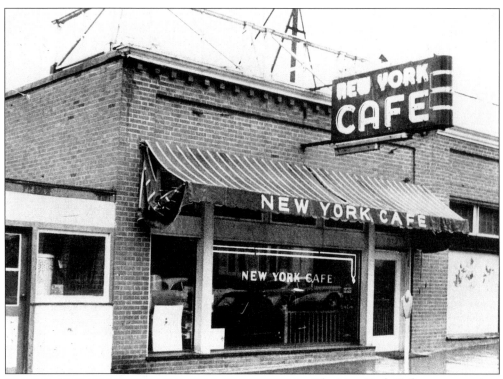

The New York Cafe was a premier eatery on Main Street in Middleburg until 1958, when it was bought out and renamed The Coach Stop. It remains in operation today. (Photo courtesy of Howard Allen Studios.)

Notable people often visit downtown Middleburg. Willard Scott, who lives nearby in Delaplane, Virginia, is one such person. Mr. Scott has portrayed Ronald McDonald and has, for many years, been a radio and television personality. (Photo courtesy of Howard Allen Studios.)

Vice President George Bush addresses the Virginia Federation of Republican Women at Sen. John Warner's Atoka Farm, just outside of Middleburg. (Photo courtesy of Howard Allen Studios.)

Many famous people come to the Hunt Country for the races, including such notables as Mrs. Ellie Wood Keith, Vice President Alben Barkley and his wife, Bing Crosby, and Mrs. John Hay Whitney (later Liz Tippett). This is a view of the Piedmont Hunt Race Course at Llangollen in the late 1930s. (Photo courtesy of Howard Allen Studios.)

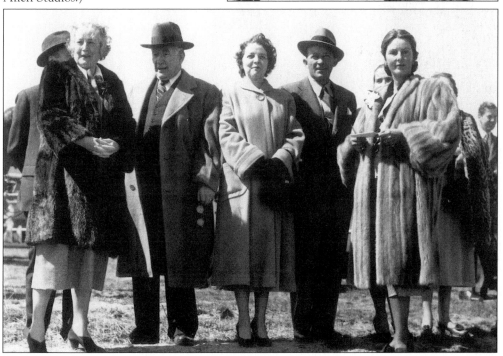

The Middleburg A&P, which became the Middleburg Safeway in the late 1930s, presently houses the Middleburg Hardware Store. Pictured from left to right are as follows: "Shaky" Nalls, Curtis Ambler, Iden Mallory, Elmer Baumgardner, and Huck Downs. The B&A Grocery nearby was started by Baumgardner and Ambler.

This home, near Middleburg, is made of rubble stone and has had several nineteenth-century additions to the rear and side. (Photo courtesy of John Lewis File at Balch Library.)

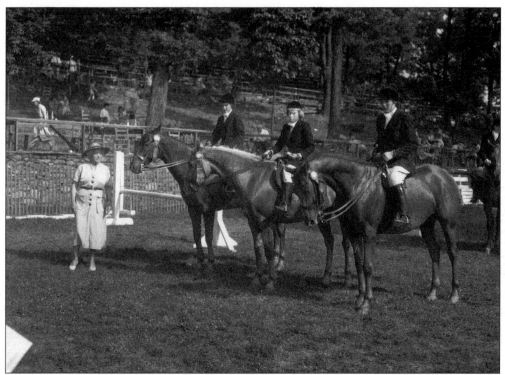

Equestrians from all over the world come to the area to take part in many events. These photos show the Middleburg Horse and Pony Show in 1953.

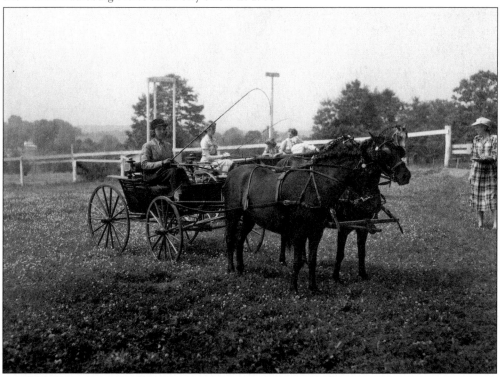

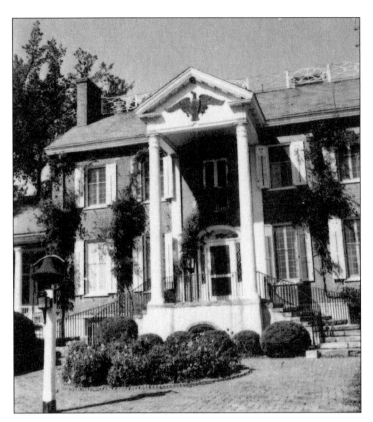

Benton, located near Middleburg, was built in 1837 by an Englishman named William Benton, who was the foreman for the builder of Oak Hill, James Monroe's home. The house was also known as New Lisbon and is presently called Huntland. It was given to James Monroe Benton just before the Civil War, and an addition was built in 1915. In 1954, George R. Brown of Texas purchased the home and renamed it Huntland. President Lyndon B. Johnson visited there and during his visit suffered a heart attack. Speaker of the House Sam Rayburn also visited this historic home.

Dover Farm, located just outside of Middleburg on Route 50, was built c. 1800 of rubble stone. It has had several additions and was part of a large horse farm.

The area east of Middleburg is known as Dover. This house at Dover was built by the Hixson family in 1804. The McCormick family owned the property for several generations. For a time, Dover was a school. The stone structure (bottom) is referred to as the slave quarters at Dover. Exact dates are unknown.

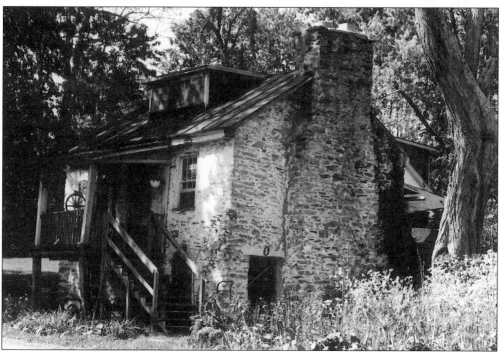

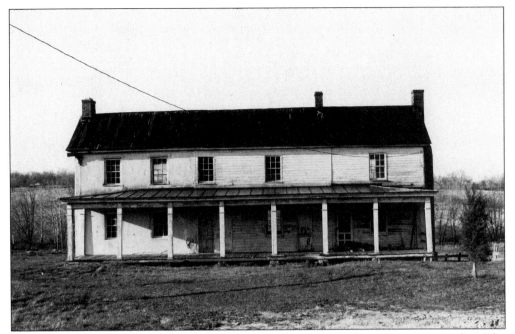

Just outside of Middleburg is the Piggott house, built *c.* 1743 by Isaac Piggott, a Quaker. The house is located on Route 611. It was once known as Dinwiddie and was owned by O. Irvin Beavers until 1970. This is a view of the house in 1976, prior to recent renovation. (Photo courtesy of the John Lewis File at Balch Library.)

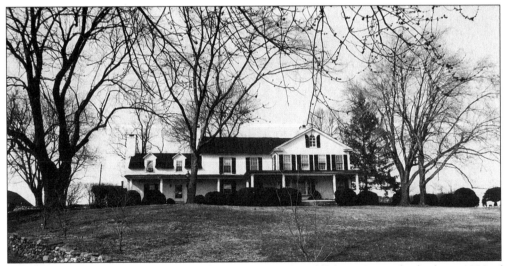

Briar Patch is a lovely dwelling located just outside of Middleburg. It was built about 1800 of logs, and later additions were of rubble stone and frame. (Photo courtesy of John Lewis File at Balch Library.)

Six

THE TOWN OF
PURCELLVILLE

Purcellville's first recorded grant was in 1740 from Lord Fairfax to Gedney Clark, who named the area Bonaventure. With Quaker migration to the area from Bucks County, Pennsylvania, in the 1760s, the area flourished. By 1922, it had a post office, a general store, and a hotel. Purcellville enjoyed a long engagement as a major route for travelers over the Blue Ridge from 1760 to the 1990s. With the addition of the Route 7 bypass, the town continues to grow.

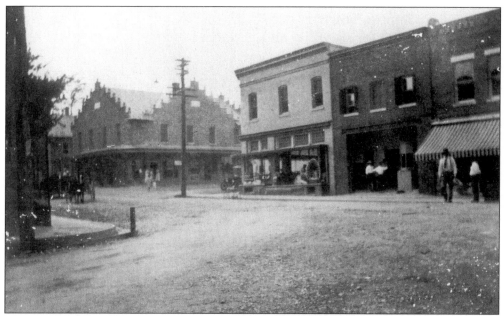

This was Purcellville's Main Street in the early 1900s. The right corner building is now the White Palace restaurant. The three buildings on the left have housed offices and antique shops since the 1920s.

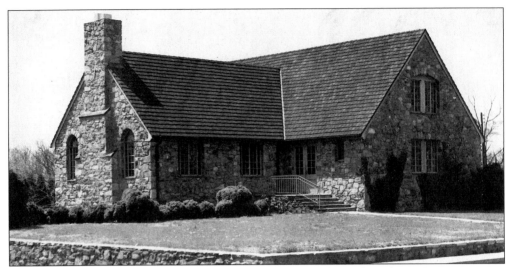

Purcellville had a free library as early as 1919. In 1920, the Blue Ridge Library Association was founded. It was spearheaded by Mrs. Gertrude James Robey. The present library was dedicated in 1938. The Robey Foundation endows the library to this day.

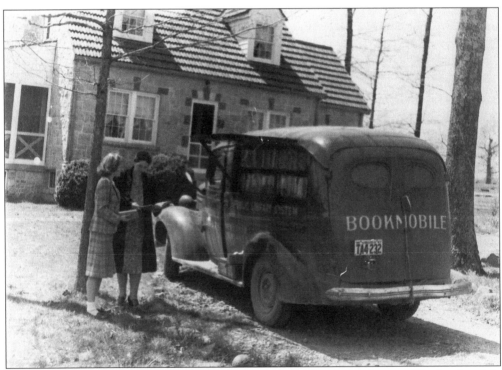

Librarian Jean Carruthers is helping a patron with her bookmobile selection. The bookmobile has been replaced by outreach services sponsored by the Loudoun County Library System.

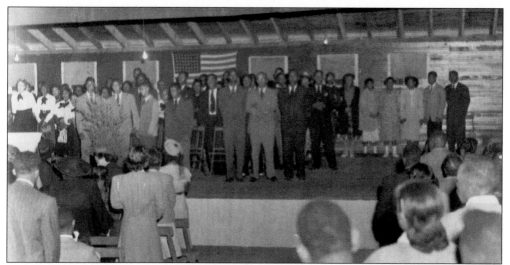

Purcellville has always had a large African-American population. This photo, taken in September 1941, shows the Loudoun County Emancipation Association Inc. in a meeting.

Bellmont, located in Purcellville, was built prior to 1799. In 1803, it was owned by the Braden family until 1898, when it was sold to E.B. White. There is an old mill that was operated under the name Wood's Mill, and later Virginia Mills, until about 1920. (Photo courtesy of the John Lewis File at Balch Library.)

The old Copeland homestead near Purcellville was built between 1765 and 1803. James Copeland, a Revolutionary War soldier, and his friend General Morgan built the second floor of the house in 1803. (Photo courtesy of the John Lewis File at Balch Library.)

The Asbury Methodist Church, just outside of Round Hill, was built c. 1888. It was used as an African-American church until the 1960s and was then abandoned. There is a small cemetery in back of the church that has only a few marked graves.

Seven

THE TOWN OF
ROUND HILL

This town dates back to 1731, with the first grant from Lord Fairfax to Benjamin Grayson. Round Hill became a boom town when the Washington and Ohio Railroad put in a train stop in the 1870s.

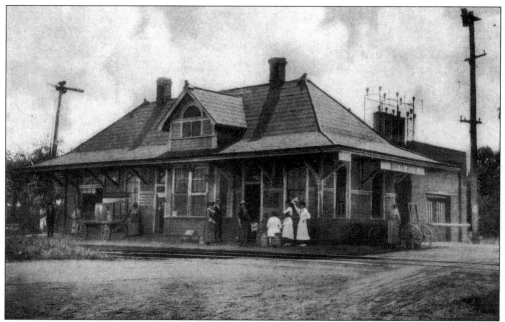

Round Hill was a popular summer resort area from 1870 to 1880. The train gave easy access to Round Hill from Washington, D.C. This is the second train station on Main Street.

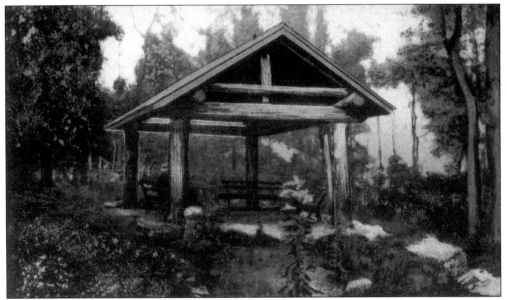

During the 1890s and well into 1900, many trails and retreat areas were set aside for tourists. This one was very popular. Bear's Den was a large resort area at the top of the Blue Ridge Mountains.

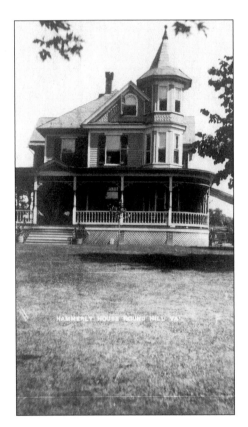

Near the turn of the century, many Victorian houses sprang up in Round Hill. This one, built in 1898, is known as the Landon O. Hammerly House. It is located on the corner of West Loudoun and North Locust Streets. (Photo courtesy of Helen Hammerly Shedd.)

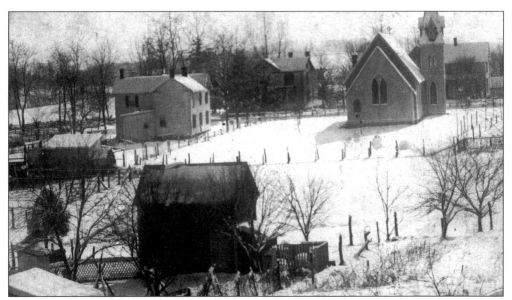

This is a panoramic view of the back of Mount Calvary Episcopal Church, located at 16 East Loudoun Street, Round Hill. Looking south, in the foreground, is Earl Poston's stable. To the left of the church (18 East Loudoun Street) is James A. Cummings's lot and home, which was built in 1891 by local developer Barney Noland. It was later called Harve Fields house. Corner Hall, across the street at 19 East Loudoun, was the home of James Cross and his daughter, Nannie (Mrs. William) Ballenger, who ran a tearoom there until the early 1960s. It was built in the early 1890s. Mt. Calvary Episcopal Church, located at 16 East Loudoun, was built in 1892 on a lot bought from Barney Noland. Across the street, at 17 East Loudoun, is the home of Town Recorder Johnson Taylor. This picture from the collection of Pete Gray was taken prior to 1903, when the house at 14 East Loudoun was built.

The Everhart House is now located on New Cut Road in Round Hill. It was built in 1910. The couple in the yard are Luther Everhart and his wife. (Photo courtesy of Pete Gray.)

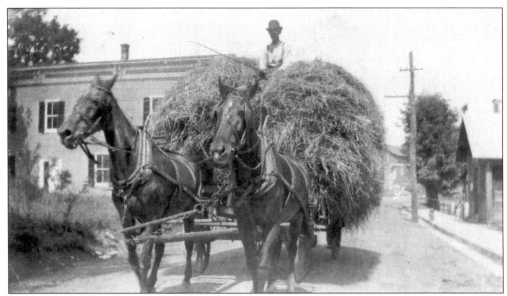

This picture was taken between 1880 and 1900. It shows a haywagon on Main Street in downtown Round Hill. Billy Hall's store can be seen on the right, and Paxson-Lodge's Hall is on the left.

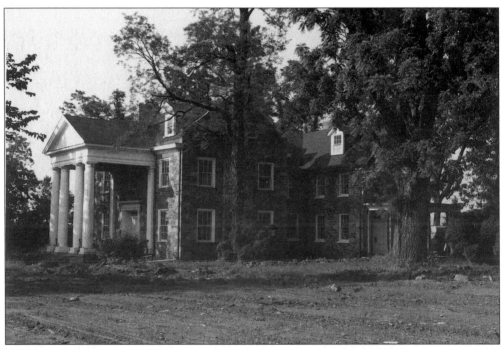

Woodgrove Plantation, constructed in 1780, is located near Round Hill. At the turn of this century, Woodgrove was a dairy plantation with a Methodist church, four houses, and a log cabin. The house was built in three parts by Nicholas and Mary Osburn. The oldest section of the house dates back to 1735. (Photo courtesy of the John Lewis File at Balch Library.)

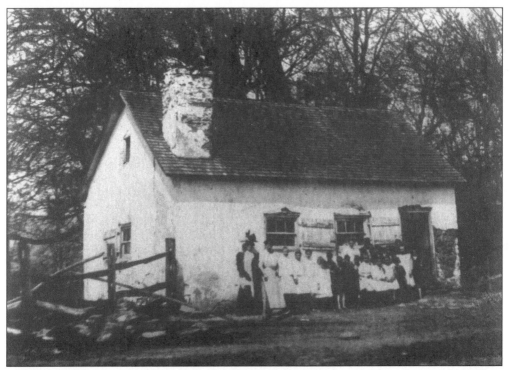

This is a 1900 view of the one-room schoolhouse at Woodgrove. The last class was held there *c.* 1912. It was then called the Grove School.

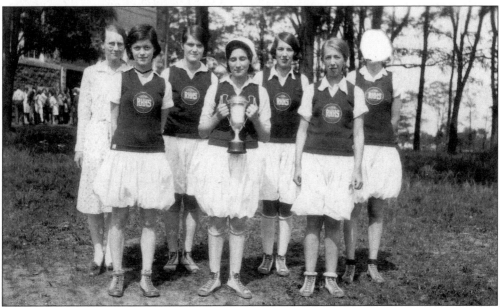

Round Hill High School's girls' basketball team were the champions in 1929 and 1930. Team members are, from left to right, as follows: Juliet Jones, teacher and coach; Nancy Casey; Pauline Payne Virts; Ann Larick Gulick (holding cup); Sadie Morris; Alice Morris Allder; and Helen Hammerly Shedd (her face in this picture was clipped out and placed in friend's pocket watch).

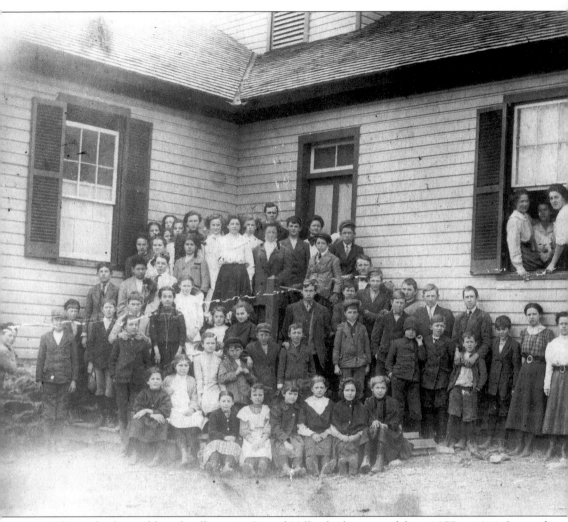

This is the first public schoolhouse in Round Hill, which operated from 1877 to 1911. Located on Church Street, at the site of the present Methodist Parsonage, it burned in 1911. The class pictured was the last to use the school. Class members include, in no particular order, Cecelia Thomas (Folk); Alice Williams (Whitely); Ruth Hammerly; Owen Thomas Jr.; Agnes Tracy; Florence Tracy (who later married Buck Beans and worked at the post office in Round Hill); Roger Wilson; Frank Wilson; Josephine Williams; Gladys Thomas; Lodge Paxson; Leslie Bagby (with the bat); Herbert Poulsen; Frank Martz; Hilton Martz; Nell Moore; Garrett Harrell; Charlotte Poston; Lydia Barton; Nelson Davis; and Willard Herrell. (Photo courtesy of Helen Hammerly Shedd.)

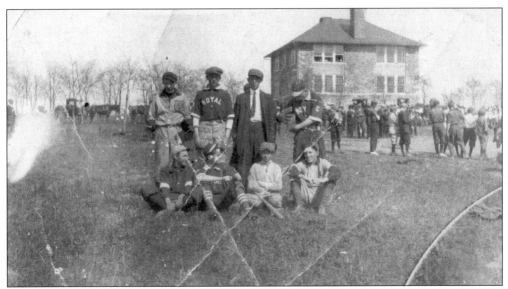

This photo was taken c. 1930. The Round Hill High School, built c. 1912, is shown in the background. Wilmer Baker was the stonemason who worked on the school building.

Ketoctin Baptist Church is located on Routes 711 and 716. Built in 1854, this church is the fourth building for the Baptist congregation in Round Hill. Church meetings in Round Hill began in 1751.

This photo of the Round Hill Methodist Church was taken c. 1952. The building was dedicated in 1889. The Reverend J.H. Dulaney preached the first sermon in the building on May 12, 1889. The congregation met at Woodgrove prior to that time. (Photo courtesy of the Winslow Williams File at Balch Library.)

Eight

VILLAGES AND CROSSROADS

There are many small villages in Loudoun County, and each one is unique. The villages are usually ethnically diverse and have retained much of their Old World charm and customs. Some have simply suffered the consequences of time and today have only historical significance.

Located on Route 50 east of Middleburg, Virginia, Aldie was named for Aldie Castle, the ancestral home of the Mercer family in Scotland. Its two mills were the stabilizers of Aldie's economy. The town had an established post office by 1811.

Shown in this view is the Country Mill, which was built in the late 1700s. A "gristmill" or tub mill that primarily ground wheat and corn, it is part of four buildings that now comprise the Aldie Mill complex. This photo was taken by Steve Spring.

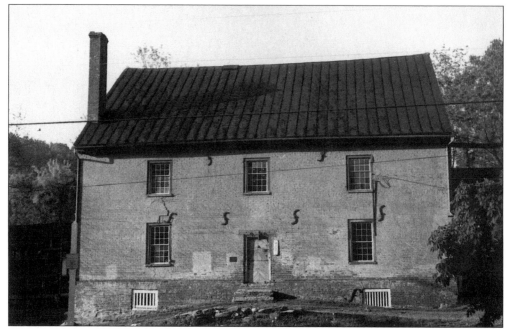

Built by Charles Fenton Mercer in 1807, Aldie Mill was also known as Mercer's Mill. Mercer sold the mill to Capt. John Moore in 1835, and Moore's descendants ran the mill until 1981, when Mr. and Mrs. James E. Douglass donated it to the Virginia Outdoors Foundation. Aldie Mill is being restored with the help of private donations and Federal Highway Enhancement (ISTEA) funds. In the near future, it is scheduled to be a water-powered gristmill. Aldie Mill is located at the beginning of the historic Little River Turnpike and survives as Virginia's only known mill powered by twin-overshot waterwheels. This view was photographed *c.* 1978. (Photo courtesy of the John Lewis File at Balch Library.)

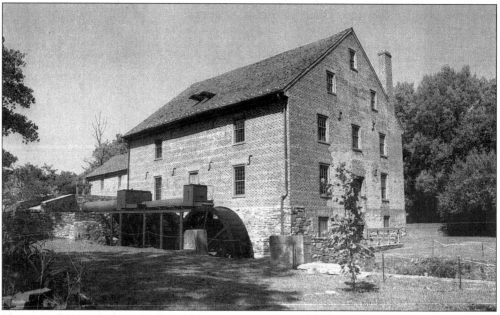

Shown in this 1998 photo by Steve Spring is a rear view of Aldie Mill.

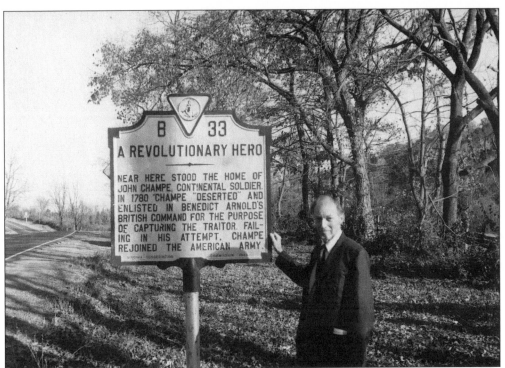

Many Loudouners fought in the Revolutionary War. John Champe was one of the more colorful men to serve. His monument is located in a pasture off Route 50 near Dover, Virginia. The U.S. Highway Department has it well marked.

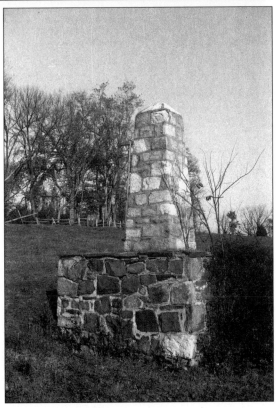

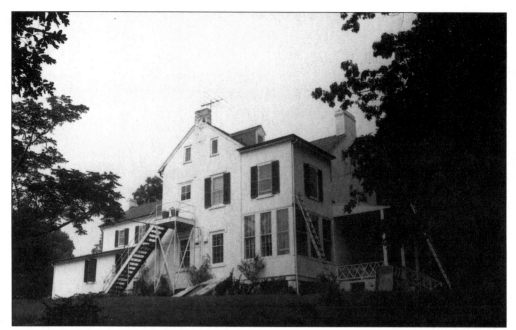

This was the home of Charles Fenton Mercer. The Mercer family founded Aldie and started the milling industry there. The Virginia Highway marker below stands on Route 50, directly in front of the Mercer Home.

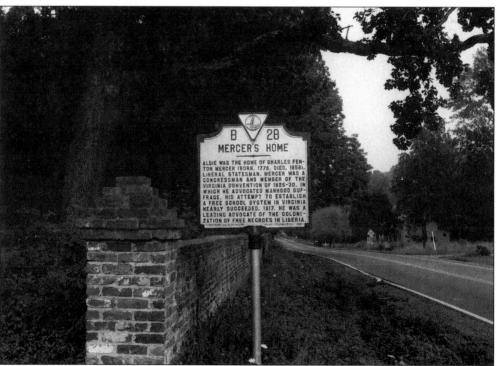

ASHBURN. The Village of Ashburn dates back to 1720. It was part of a tract of land that was purchased by Thomas Lee and Robert "King" Carter. The major claim to Ashburn's fame was that it boasted a mail pick-up stop on the Alexandria-Loudoun-Hampshire Railroad in the mid-to-late 1800s.

Narrowgate depicts an early nineteenth-century brick house with Flemish Bond brickwork. It has had several additions. The house is located on Route 50, which is the main street through Aldie.

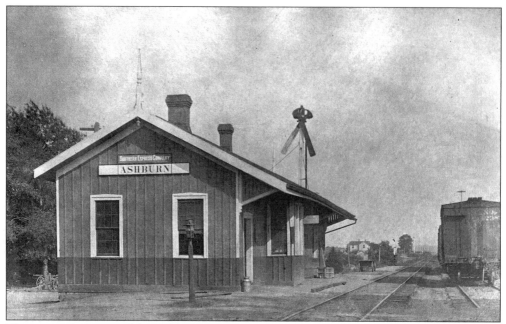

This is a c. 1910 view of the Ashburn railroad station. The town was a very rural area until the growth spurt of the 1950s. Ashburn is presently a large, suburban community.

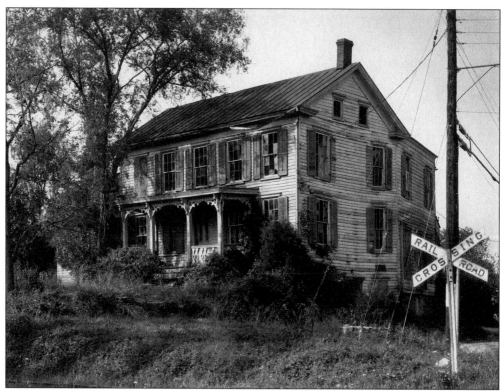

This abandoned house near Ashburn was once used as an inn to welcome travelers who arrived by train.

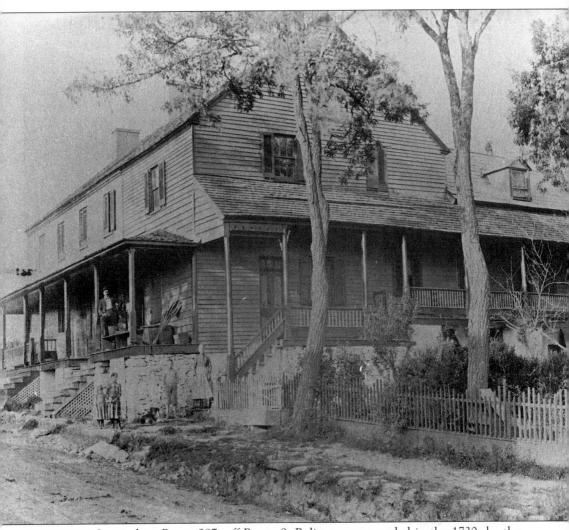

BOLINGTON. Located on Route 287, off Route 9, Bolington was settled in the 1730s by the German families of Grubb, Hickman, Kunard (or Cunard or Conrad), Shumaker, Virts (Wertz-Vertz), and DeKalb, all from Pennsylvania. The village was named in honor of Daniel Boland, a resident in the 1850s who served as postmaster.

This photo is a copy of an 1890 plate negative. The Brooks family of Bolington is pictured from left to right as follows: Samuel Webster Brooks, Mary Grace Brooks, Goldie DeKalb Brooks, Harry Hickman Sr., Susan Jeanette Mann Brooks, and Spot.

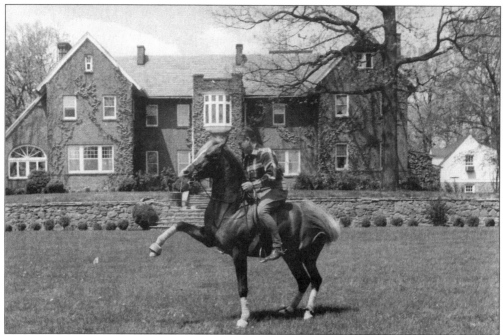

BEACON HILL. This area is neither a town nor a village. It was a 2,000-acre estate purchased by radio-television personality Arthur Godfrey in 1946. Many of his television shows were broadcast from the buildings at Beacon Hill. Godfrey was generous to the Loudoun community. He contributed to the Loudoun Memorial Hospital and gave Godfrey Field to the Town of Leesburg. It is now Leesburg Municipal Airport. His pride and joy was his well-trained horse, Goldie. This photograph was taken in back of the Beacon Hill estate in the 1950s. It shows Arthur Godfrey taking Goldie through her paces. The estate of Beacon Hill has now been subdivided for homes.

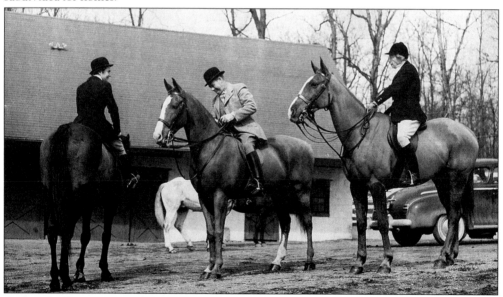

Arthur Godfrey was a good equestrian and huntsman. This photo was taken near the barns and stables at Beacon Hill.

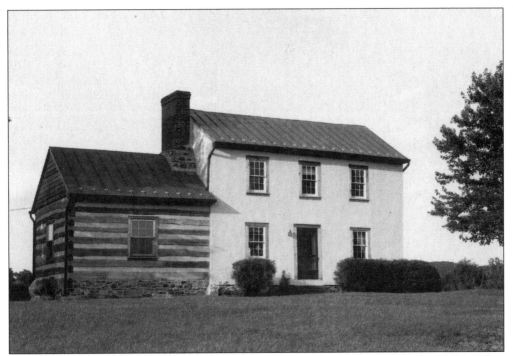

BLUEMONT. One of the older villages in Loudoun County, Bluemont dates back to 1730. It has been called Snickersville, or Snickers Gap (after its founding family), and is located near the Fauquier County line in western Loudoun County.

The Kelley House on Route 734, pictured here, is a log-and-stone structure built *c.* 1803, when the property was owned by Bushrod Washington. The house had many owners. In the 1980s, James Kelley did some major renovation to the home. (Photo courtesy of the John Lewis File at Balch Library.)

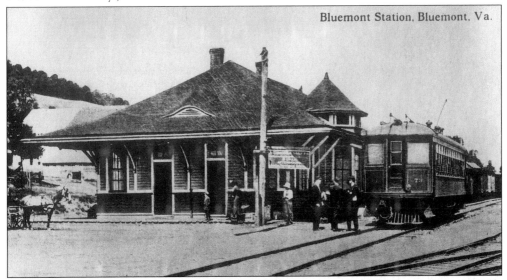

Bluemont Station, Bluemont, Va.

Bluemont train station is shown here at the turn of the century. Many Washingtonians came to Bluemont (Snickersville) to escape the hot Washington summers and visit the numerous retreats in the area.

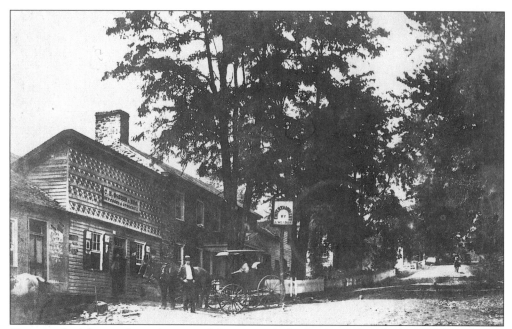

Photographed during the early years of this century, this house is identified on the back by the following inscription: "Bluemont House (Stone House), Alfred and Margaret Chew's Home, Birthplace of Orlando Glascock and Roger Chew Glascock. On the left side of the road going into Bluemont, formerly Snickersville. Roger Glascock is standing in front." It is signed by Clyde Chew Glascock.

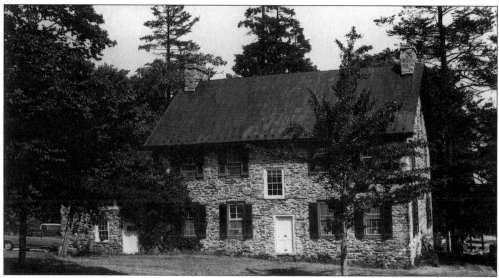

Clayton Hall, built in 1797, is one of the largest and earliest homes in Bluemont. It was originally part of Lord Fairfax's estates in 1749. William Clayton was one of the first owners of Clayton Hall. According to legend, Clayton, a Tory during the Revolution, betrayed the Continental Troops to the British. The home has been used as a roadhouse and a tavern over the years. The present owner, Evelyn Johnson, maintains the historical integrity of the house and is an active preservationist and historian for the Bluemont community. (Photo courtesy of the John Lewis File at Balch Library.)

The Bluemont Post Office is the town meeting center where old-timers and newcomers meet and discuss everything from the weather to moon rockets. The post office has been a mainstay since 1807, when the "Snicker's Gap" post office opened with Levin Stephens as the first postmaster. In 1830, the village became known as Snickersville. The postmaster at the time was Perrin Washington. In 1900, the village's name was changed to Bluemont, and James F. Osburn took over as postmaster.

This building was constructed c. 1900 for Dora Simpson. In 1907, it was called Lake Store and was operated by E.E. Lake. The post office addition was built in 1918, and Earl C. Iden became the proprietor in 1919. The building is presently being restored and preserved by concerned Bluemont citizens.

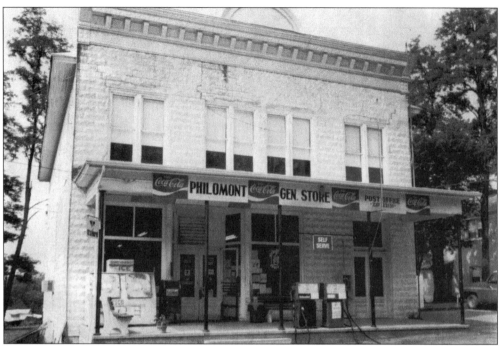

PHILOMONT. In 1739, this small village was British property. The name Philomont comes from the Greek "Philos," meaning mountain. The post office/general store is the main attraction.

Shown below in this c. 1978 view is Hibbs Bridge, located on the Snickersville-Aldie Turnpike (near Philomont). Built between 1822 and 1835, it is one of two remaining bridges in Loudoun County that are two-barrel stone, one-lane bridges. It spans Goose Creek. Hibbs Bridge is named for Stephen and William Hibbs, the bridge's owners in 1857.

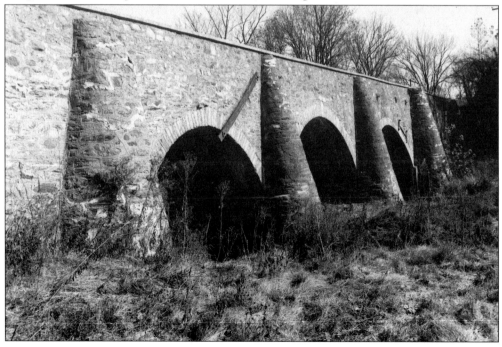

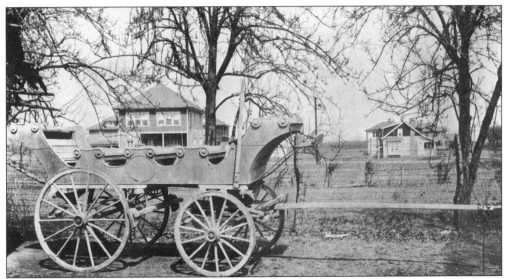

Shown here is the Philomont Cornet Band bandwagon, designed by Prof. J.R. Turner of Staunton. It was built *c.* 1872 by Jonah Tavenner, and the iron work was done by Stewart Steele of Purcellville. James Turner Dillon loaned it to the Winchester Apple Blossom Festival in 1930 and it was never returned. The wagon had a seating capacity of 12—the exact number of men in John James Dillon's band.

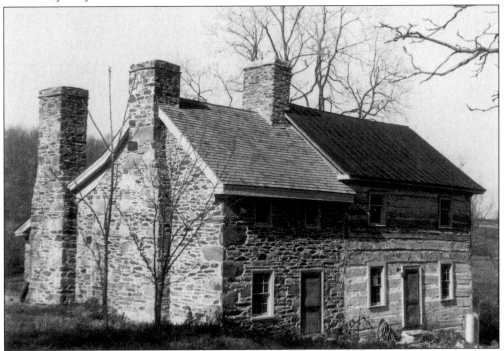

The Gregg House, located near Philomont, was built *c.* 1800. Thomas Gregg of Chester County, Pennsylvania, deeded the property to Josiah Gregg in 1788. It remained in the Gregg family until 1851. At that time, it was sold by Gibson Gregg to Samuel H. Nichols. Samuel owned the property until 1921, when Charles F. Otley purchased it. It has had major restoration done recently.

HUGHESVILLE. This village was located on the first road designated as a shortcut from Williams Gap to Leesburg in 1759. Named for the Hughes family, who owned large tracts of land in that area, Hughesville had its own post office from *c.* 1807 to the 1930s.

Pictured here was all that remained of the store and post office in Hughesville in 1952. The building was built between 1846 and 1852 on land that was part of the Amos Janney tract in 1742. The Hughesville post office distributed mail form *c.* 1870 to 1905. Its previous postmasters include Thomas Hughes, Samuel T. Canby, John H. Hughes, Jesse Hoge, James W. Plaster, Henry Haley, Mary Hoge, and Leonidas G. Caviness. (Photo courtesy of the John Lewis File at Balch Library.)

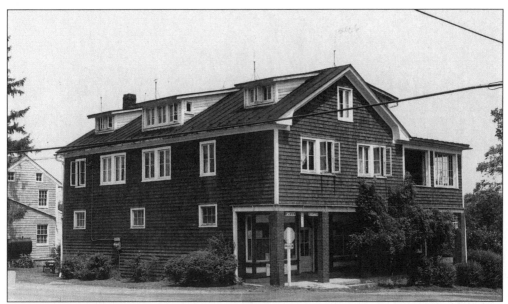

LUCKETTS. This village was named for the Luckett family of Loudoun County. In 1757, Thomas Hussey Luckett founded the town. It boasted an active store until 1948, when Roger Luckett, a descendant of the founding family, died and his wife, Mae Arnold Luckett, took over the operation of the store until it closed in 1955. Lucketts had a post office as early as 1880.

Lucketts store was built by Samuel Luckett *c.* 1900. It has been a general store, beauty parlor, apartment house, and antique shops. It is located on Route 15, near Lucketts School. (Photo courtesy of the John Lewis File at Balch Library.)

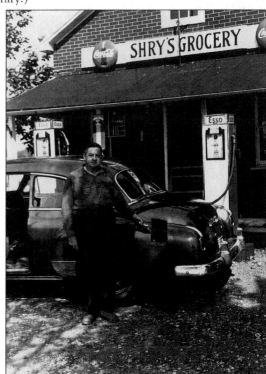

This photo was taken in the 1940s. Judge Shry is shown here pumping gas at Shry's Store. Shry family members have lived near Lucketts, at a crossroads known to locals as "Lost Corner," for over 100 years. (Photo courtesy of Winslow Williams.)

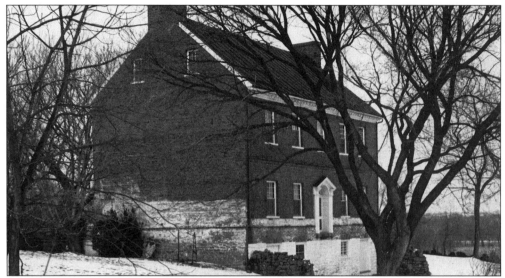

GORESVILLE. This village was named for Thomas Gore of Montgomery County, Maryland. He married Sarah Neighbors in 1764. In the 1860s, Paxson store served as a voting precinct. Goresville post office was in use from 1854 to 1892.

Noland's Ferry lies just north of Lucketts, on Route 15. It was built *c.* 1775 by Philip Noland, who ran the ferry near his home. The house was abandoned for over 20 years and was in a state of decay when Mr. and Mrs. W.G. Brookins restored it in the 1960s. This photo was taken by E.B. Wilson *c.* 1963.

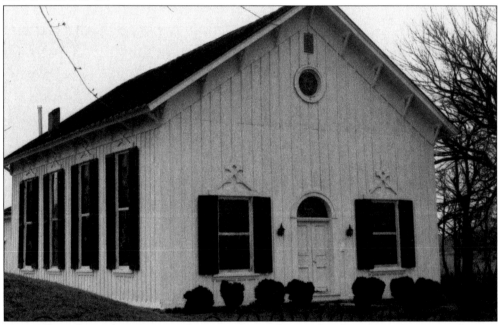

Goresville is located on Route 15, just a few miles south of Lucketts. It was a thriving community in 1880. This church was started in 1773. Since 1961, local families such as the Whitmores, Howsers, Chichesters, Heflins, Jacksons, Flemings, Wynkoops, Willards, Myers, Smallwoods, Flynns, and Kohlhosses have endeavored to preserve the church as a local landmark.

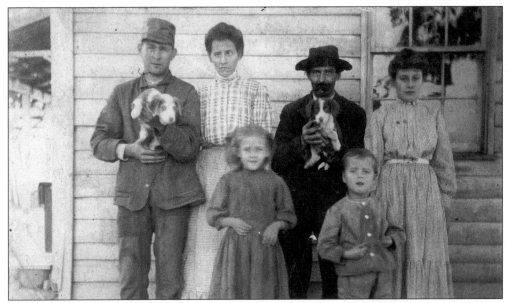

STUMPTOWN. This small, mountain community located just outside of Lucketts was founded in the 1850s by David W. Fry, who cleared the land and helped build the local church. It was primarily a German settlement until the 1950s, when development began in the area.

This photo of the Cooper family was taken c. 1915. It shows the rural family on the porch of Stumptown Store. Pictured from left to right are as follows: (front row) Ruby Lee Barnhouse and Clifton Cooper; (back row) Clarence Barnhouse, Sarah Fry Barnhouse, George Harper, and Bertie Rosella Cooper.

NEERSVILLE. Up Between the Hills, sometimes called Neersville, is located on the road between Hillsboro and Harper's Ferry. In the 1770s, Henry and Conrad Neer owned much of the land in the area. Several major churches and an area called Porter's Store comprise Neersville. It had a U.S. post office from 1839 to 1907.

This is what remains of the Potts-Neer Mill located just outside of Hillsboro. It was one of over 70 mills in Loudoun County. It was still operating in 1768 as a water gristmill, and in 1819, it was remodeled. The Potts and Neer families were early settlers of Neersville. They were prominent agriculturalists and businessmen.

Built *c.* 1820, this store (seen above) at Neersville was in business for almost 140 years. In 1869, W.C. Galloway sold his store to Daniel Miller and Company. In 1876, Daniel Miller sold the store to John F. Porter and it became known as Porter's Store until 1946, when it was purchased by G. Roy Hess, who ran a filling station and general merchandise store. The store (far left) and the storeroom (right) are now abandoned. The Porter/Hess house (pictured below) is presently undergoing extensive renovations.

St. Paul's Lutheran Church is prominent in Neersville. It was a German Lutheran church built in 1835. The church building and cemetery are used even today. The church has annual meetings and family get-togethers several times a year.

Neersville School is a well-preserved, stone schoolhouse located in western Loudoun County. It was built about 1885. Today, it serves as a private residence.

LINCOLN. Known as Goose Creek in the 1740s (so named for the Goose Creek Quaker Meeting), this village was re-named in honor of Abraham Lincoln, who appointed the village's first postmaster, Rodney Davis. Today, Lincoln is a thriving Quaker community that has retained its quiet charm for over 250 years.

Pictured is Goose Creek Meeting, which was built for worship by Quakers between 1765 and 1770. It served as a house of worship for 50 years before it became a caretaker's house. Four generations of the Taylor family lived there. It continues to serve as a caretaker's house.

Asa Moore Janney's store in Lincoln was built in 1874 as a town hall for the village of Lincoln. The store was opened in 1928. The store and post office operated well into the 1990s. Asa Moore, the longtime proprietor of the store, is a direct descendant of Jacob and Hannah Ingledew Janney, the founders of the Goose Creek Meeting.

Runnymeade Farm was part of an original land patent granted from Lord Fairfax to Mary Janney in 1754. It was comprised of nearly 469 acres. In 1840, Elias Hughes began construction on the house but abandoned the project for several years. The house was completed *c.* 1850 by Thomas Hughes. (Photo courtesy of the John Lewis File at Balch Library.)

Hillbrook House, built between 1800 and 1870, is located near Lincoln. The original property was granted by Lord Fairfax to John Gregg. It was comprised of 670 acres at that time. The house was built by Hamilton Rogers and has been in the family for generations. (Photo courtesy of the John Lewis File at Balch Library.)

The Goodin House is located near Lincoln. In 1760, Mahlon Janney deeded 116 acres to Amos Goodin on the south fork of Kittoctin Creek. In 1801, Amos willed the plantation to his son, David, and his wife, Anna. It was sold at auction in 1906 and left vacant in the 1950s.

Coolbrook House is located near Lincoln. The original part of the house was constructed in the early 1800s by Jacob and Hannah Janney. An addition was built in 1827 by H.S. Taylor, a descendant of Jacob and Hannah Janney. The Taylor family has retained ownership of the property for generations. (Photo courtesy of the John Lewis File at Balch Library.)

The David Young House was built c. 1800 of rubble and brick. It remained in the Young family for almost 50 years until it was purchased by Benjamine "Tobe" Simpson. Simpson was one of Mosby's men. The house remained in the Simpson family until the 1970s.

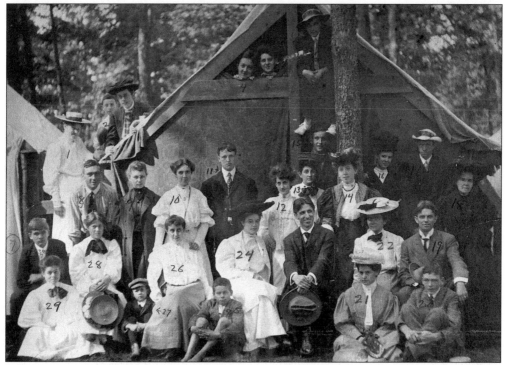

Bush meetings and camp meetings were popular for many years in western Loudoun County. This photo, taken at a Bush meeting, identifies the following people: Mrs. A.H. Spitler, Eugene Forsythe, Elizabeth Rogers, Walter J. Tiffany, Edwin Fred, Lucy Compton, Conway Brown, Mrs. Hugh Keen, Laurence J. Martin, Ida Ross Chamblin, William Skinner, Mrs. Jack Priest, Walter Fred, Suella Priest Hough, Miss Nanny Fred, and Helen Gibson. At least eight people cannot be identified due to the age of the picture. The exact site of this photo is not known. It was probably in the Purcellville or Lincoln area.

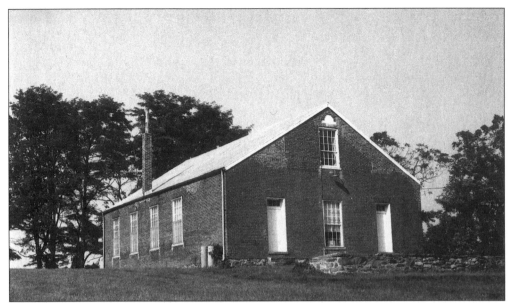

NORTH FORK. This small village had an established U.S. post office as early as 1836. In the 1880s, the post office and the area were called Brown's Post Office (T. Janney Brown was the postmaster). In 1878, the name was changed to North Fork, and the area maintained a post office well into the 1930s.

North Fork Regular Baptist Church was organized in 1835. This building was built in 1856. The building was originally two stories tall, but in 1949, the top floor was blown off. (Photo courtesy of the John Lewis File at Balch Library.)

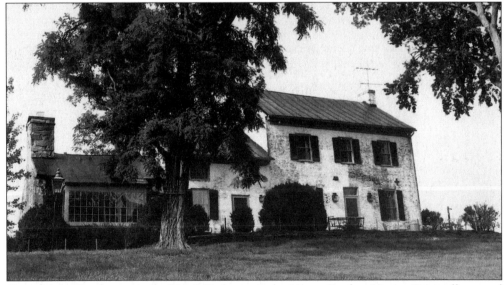

One of the oldest homes in the North Fork area is the Minor-Bartlow House. Originally owned by Jacob and Hannah Ingledew Janney in 1742, it was deeded to their son, Blackstone Janney. In 1815, Blackstone sold the home to his son, Eli, with 89 acres of land. In 1825, Eli sold some of the land to his sister, Hannah Janney Brown, the wife of William Brown. Their daughter married H.S. Taylor. A great-grandson, Thomas Taylor, resided there in 1950. (Photo courtesy of the John Lewis File at Balch Library.)

PAEONIAN SPRINGS. This area was a noted mineral spring in the time of Lord Fairfax. Thousands have drunk from the springs over the years. From the late 1870s to 1910, the spring water from Paeonian was bottled and sent to Washington, D.C. as the official water of the U.S. Senate. The train stopped regularly at Paeonian Springs, and the area provided a hotel and summer homes for Washington socialites.

The plaque pictured below serves as a reminder of the founding of Paeonian Springs. It is located just off the Washington and Old Dominion (W&OD) railroad beds. This is now part of the W&OD bike path. Locals called the trail the "wobbly, old and dilapidated railroad."

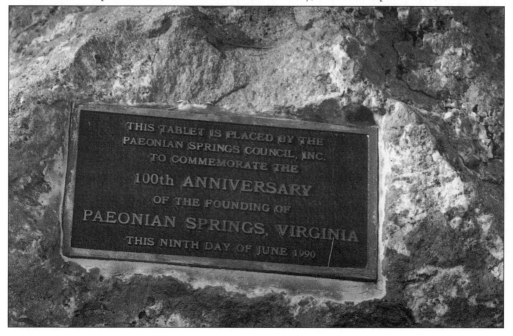

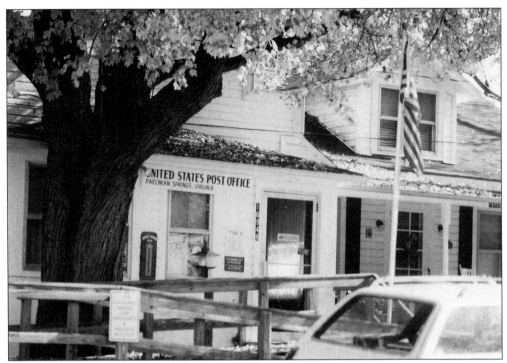

Paeonian Springs had a post office as early as 1892. At that time, Obed Pierpoint was postmaster. The current post office (pictured here) housed a general store for a number of years in the 1940s and 1950s.

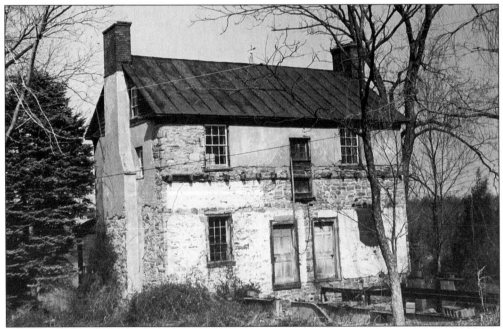

The Bates/Kirby House was built prior to 1840. It is rubble stone with plaster overcoat and has been remodeled since this photo was taken c. 1970s. (Photo courtesy of John Lewis File at Balch Library.)

STERLING. Most of the history of the Sterling area revolves around the Old Loudoun-Alexandria-Hampshire railroad. It is said that President James Buchanan stayed at the "Sterling Hotel" in 1859. Sterling was largely a farm community until the 1940s. The Sterling-Dulles area has become a large suburban community with very little farmland.

Guilford Station was the old name for Sterling in Loudoun. Guilford had a post office as early as 1860. Its postmaster was Richard H. Havener. Guilford Station became Sterling in 1872. Guilford Baptist Church was organized in 1857. The church is still active today.

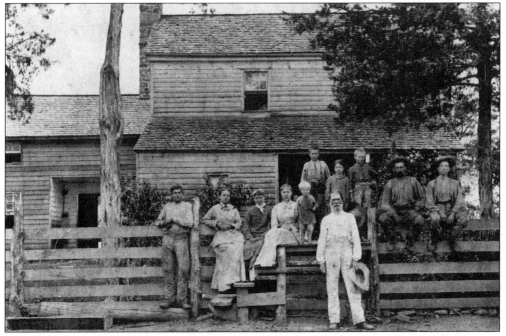

The Sterling-Dulles area has grown considerably since 1880, when George Washington Hummer and his family lived in this house on their farm. The old farm area is now the site of the new Holiday Inn on Route 28, near Dulles Airport. (Photo courtesy of Ike Hummer.)

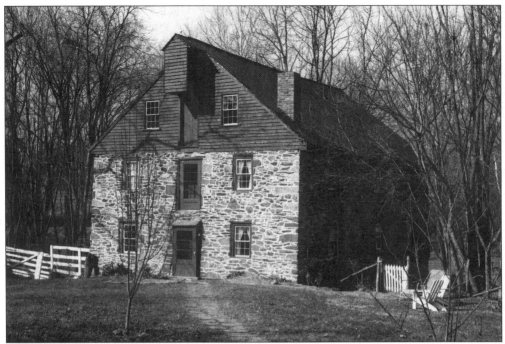

TAYLORSTOWN. This village was called Taylorstown Mill prior to 1899. Richard Brown, a Quaker, was the town's first recorded settler *c.* 1730. In the 1740s and 1750s, Taylorstown boasted a malt house, brew house, and a mill and miller's house. Taylorstown originally consisted of 1,800 acres. The mill is presently a tourist attraction. Built *c.* 1735, the mill is one of the few examples of a water-driven gristmill in Loudoun County. It is currently a private residence. (Photo courtesy of the John Lewis File at Balch Library.)

Taylorstown has many old structures. This one, which is now covered with asbestos shingles, was built about 1800. Its under-structure is frame and weatherboard. The building was at one time a store and also was used for a movie hall. (Photo courtesy of John Lewis File at Balch Library.)

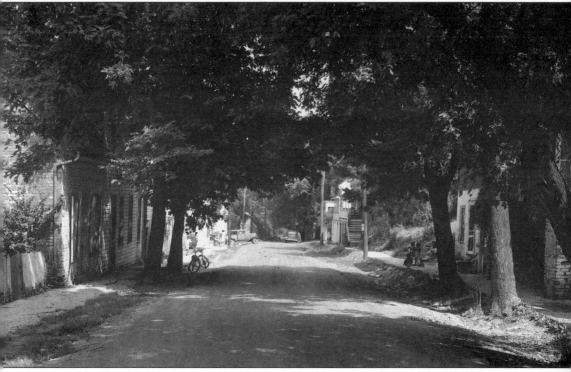

WATERFORD. This area was surveyed in 1732 by Amos Janney, a Quaker from Bucks County, Pennsylvania. Today, the Waterford Foundation protects and preserves much of the town and maintains the historical integrity of the village. Each October, thousands of people attend the Waterford Fair and tour the restored and preserved homes in that area.

Shown in this *c.* 1946 snapshot is a view of Waterford when all the streets were dirt paths. (Photo courtesy of the Winslow Williams Collection at Balch Library.)

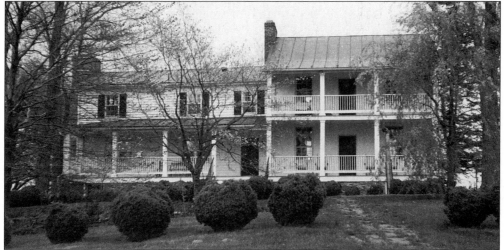

Catalpa Grove is a late 1700 log and stone structure, which has surrounding slave quarters, barns, and an icehouse. It was said to have been built by Moses Polk. The families of Colwell, Janney, and McGavick have all been inhabitants of this house. (Photo courtesy of John Lewis File at Balch Library.)

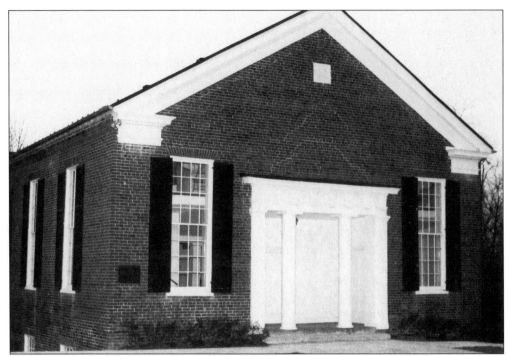

The Waterford Baptist Church was built in 1853. It suffered extensive damaged during skirmishes between Union and Confederate soldiers. It was restored to its present state in 1876.

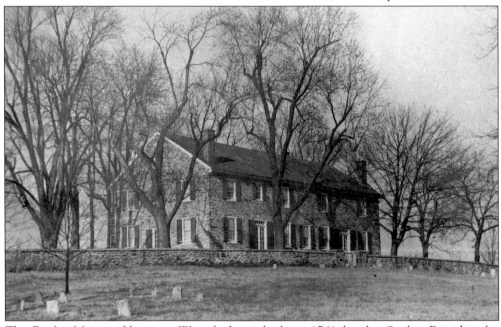

The Fairfax Meeting House in Waterford was built in 1761 by the Quaker Friends, who migrated to Loudoun County from Bucks County, Pennsylvania. During the Civil War, the house was used by Southern cavalrymen to quarter their horses. In 1867, the building was gutted by fire. It was rebuilt in 1868, and in 1939 became a private residence. (Photo courtesy of the John Lewis File at Balch Library.)

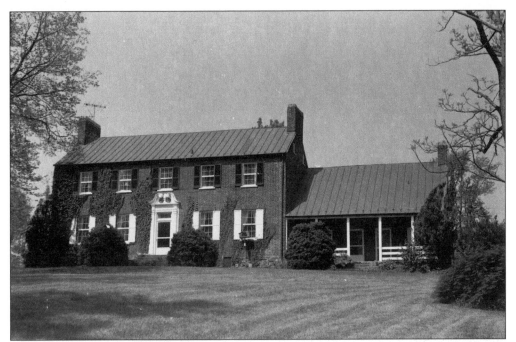

Waverly House was built in 1820 in the Waterford area. It originally belonged to James Hamilton. In the 1930s, Attorney Ward Loveless and his wife did extensive restoration and preservation work to the beautiful old home. (Photo courtesy of the John Lewis File at Balch Library.)

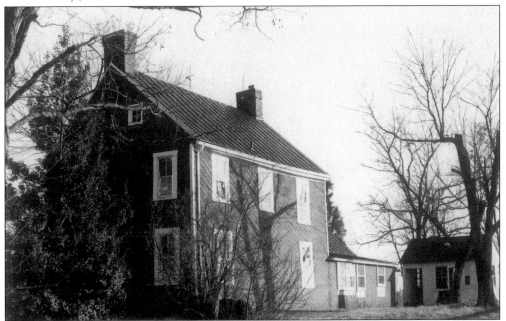

The John Wolford Farm was originally built on a grant from Lord Fairfax to Moses and Hannah Cadwallader in 1765. There has been only very minor structural changes since its construction. The farm was owned by the I.J. Virts family from 1918 to 1950. (Photo courtesy of the Waterford Foundation, Inc.)

The Weavers Cottage in Waterford is located on land owned by William Hough. In 1852, the house was sold to William Robinson, a free black man. The Robinson family owned the home until 1957. (Photo courtesy of the Waterford Foundation, Inc.)

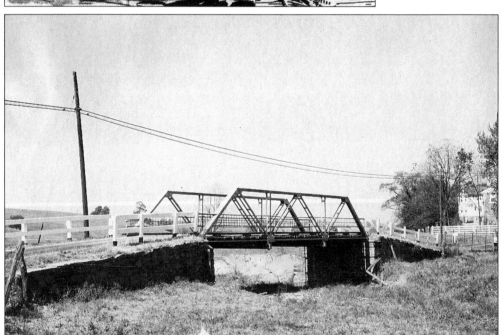

Waterford is one of the oldest villages in Loudoun. To get to Waterford, one may cross this bridge, which has been reworked several times to meet the demands of traffic. The farm pictured was owned by the Birch family. (Winslow Williams Collection, Balch Library.)

This early-1800s house in Waterford is constructed of rubble stone and square-knotted logs. Later frame additions are also visible in this snapshot, and renovations of this structure have continued since 1980. (Photo courtesy of John Lewis File at Balch Library.)

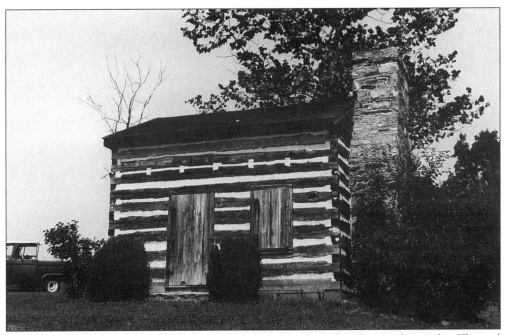

This Waterford area structure has been moved to this location from "somewhere" else. The real history of this building has not been documented. It was part of the Firestone Farm property in the 1950s and '60s. (Photograph X) (Photo courtesy of John Lewis File at Balch Library.)

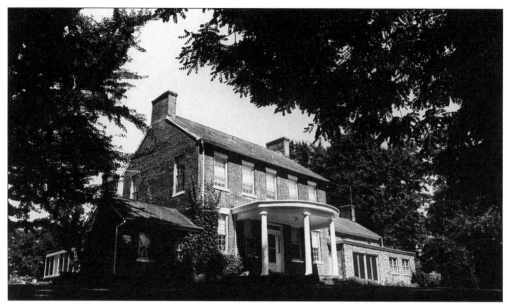

Rosemont is located on 35 private acres near historic Waterford. Rosemont has served as the manor house since the mid-1600s when the property was known as the home farm of the Fairfax holding "The Piedmont Tract." The original four-room house (now the kitchen area) was built of brick brought from England as ship ballast. The next wing of five rooms was added in the 1700s of bricks made in a kiln on the property. In 1951, the drawing room wing was added. Rosemont is registered by the Virginia Landmarks Commission. (Photo courtesy of John Lewis File at Balch Library.)

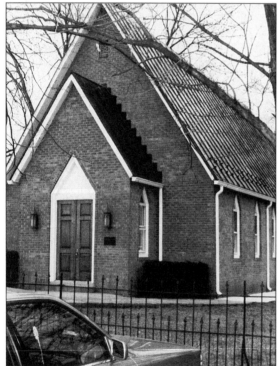

Faith Chapel is a Presbyterian church located near Waterford. It was constructed about 1880 by David Fry. The building was said to be originally frame with German siding; a brick veneer was added later. There is a cemetery attached to the rear of the church.

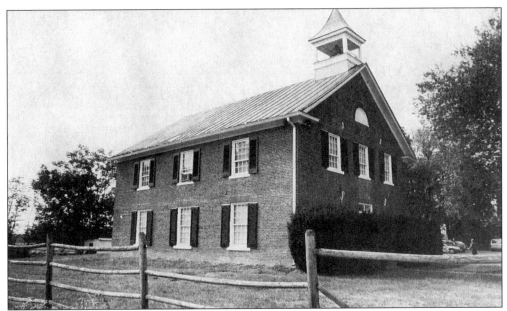

UNISON. This village boasts a Methodist Meeting House that dates back to 1785. In 1830, Unison was one of the five largest towns in Loudoun County. Founding families include the Leiths, Kerchevals, Rusts, Loves, McLinns, Robeys, Humphreys, Millers, and Plasters. Legend has it that the town was originally called Union, but during the Civil War, the town changed its name so that it would not be mistaken for a "Union" town.

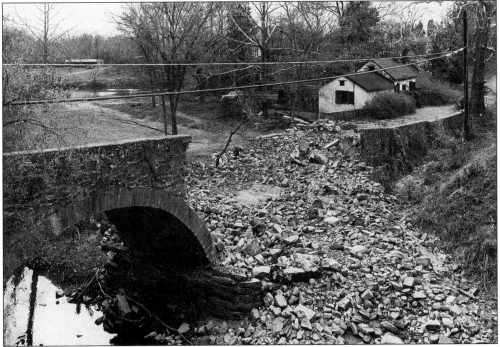

This 1973 photo by William E. Barrett depicts the "old" Route 7 bridge after a flood. The building was a tollkeeper's house. These remains are visible from the "new" Route 7, which was constructed only yards from the old bridge.

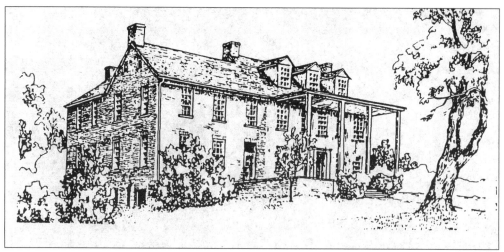

WHEATLAND. Located near the intersection of Routes 9 and 287, Wheatland was named for the area's great wheat crops. The manor house is one of the largest in Loudoun County. It is said that George Washington stayed at the manor in the 1760s. This drawing depicts the remains of the architectural design of this fine manor house.

The store at Wheatlands Crossroads, seen below, was built *c.* 1900. It had a post office and offered lodging to weary travelers in the early 1920s–30s. It served as a private residence for many years but has been abandoned since 1980.

Nine

OUT AND ABOUT

This section showcases many of the homes, churches, bridges, and other sites in Loudoun County that are not established in towns and villages. Some of these areas are known as estates bearing names that speak for themselves. Others have drifted into obscurity or are privately owned.

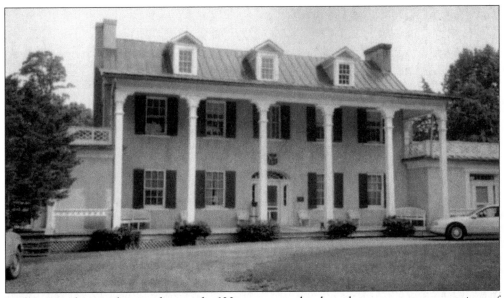

Welbourne, the grand manor house of a 600-acre estate, has been home to seven generations of the Dulany family and their descendants. The old part of the house, having never been restored, breathes an authentic atmosphere of Old South gentility. The house was built in 1775 and expanded several times during mid-19th century. In 1820, the first Dulany, John Peyton, bought the estate, and it was soon expanded to thousands of acres. His son gained recognition as a Civil War colonel of the Laurel Brigade, which was a cavalry regiment in the Confederate Army of Northern Virginia. In this century, authors Thomas Wolfe and F. Scott Fitzgerald were among the friends and guests of the family. Today, Welbourne is open to the public as a bed and breakfast inn.

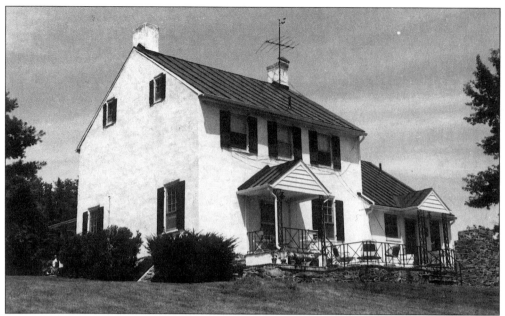

Somerset was built near Lincoln in the 1830s by Richard H. Taylor, who ran a foundry where Taylor plows, bells, and frog doorstops were made. The house has been expanded and remodeled. (Photo courtesy of the John Lewis File at Balch Library.)

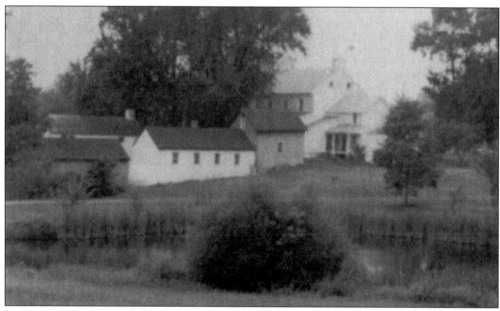

In 1814, William Burson built the Poorhouse Farm for two families. Included were several dwellings for slaves, a stone-and-frame bank barn, a cook house, and the main dwelling. An old log structure already existed on the site. The County purchased the property in 1822 to provide shelter for the underprivileged who farmed the land and sold crops for their livelihood. This program was disbanded in 1946.

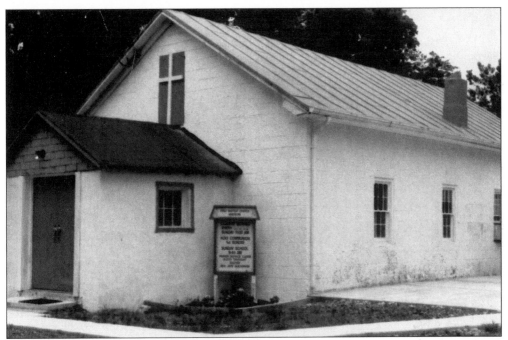

There are many houses of worship built by African Americans in Loudoun County. The First Baptist Church of Watson is a prime example. The church was organized in 1896 in the then "colored community" of Watson. The church was rebuilt in 1955. There is a large African-American cemetery located in back and on one side of the church. Today, it has an active congregation.

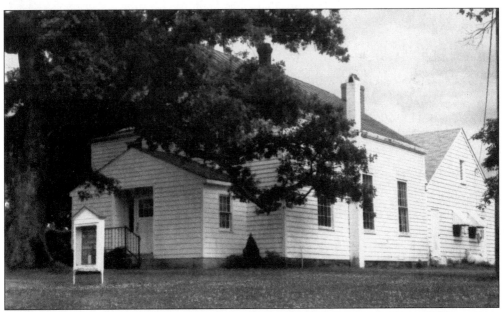

Initially, Arcola Methodist Church was a "Free Church." It was built c. 1850 at Gum Spring and has the distinction of being one of the earliest surviving churches in eastern Loudoun County.

Prosperity Baptist Church in Conklin (on the corner of Routes 620 and 621) was built in July 1899. The foundation for a new church was laid in 1952, when the Reverend S. Pearson served as pastor. The church was rebuilt in 1972 and continues to have a very active congregation. A large African-American cemetery is located nearby.

Shelburne Glebe was complete in 1733. It was the home of George Washington's chaplain, David Griffith, for a number of years. The Glebe has recently been placed on the Register of the Virginia Historic Landmarks Commission, in recognition of the historic roles it has played in our nation's history as well as for its architectural significance. During the Civil War, Colonel Mosby, the noted Confederate Ranger, was said to have been sheltered at the Glebe; a trap door in one of the bedrooms led to a hiding place from the Union soldiers. Located on a commanding rise, high above a 38-acre lake and bordered by Mt. Gilead, Shelburne Glebe provides the visitor with some of the most picturesque views in all of Loudoun County, with rolling hills extending in each direction from the manor house. The original section of the Glebe features late-Georgian architecture; the east wing (kitchen) was added in the 1850s, and the west wing was added in 1969. Handsome walnut paneling in this recent addition is from trees cut on the property. Period pieces of furniture and objects d'art abound in this serenely gracious home. (Photo courtesy of the John Lewis File at Balch Library.)

The Methodist Episcopal Church in Hillsboro was built *c.* 1865. It was deeded as a "colored church" in 1884, with Oscar Carry, Jesse Palmer, George Parker, John Lewis, and James R. Hicks as trustees.

Mount Olive United Methodist Church, located near Lovettsville, was built *c.* 1879 on land given by Judson Kalb. The stone used to build it was taken from the Kalb Farm, located nearby. The church was remodeled in 1900 and remains an active church today. (Photo courtesy of the John Lewis File at Balch Library.)

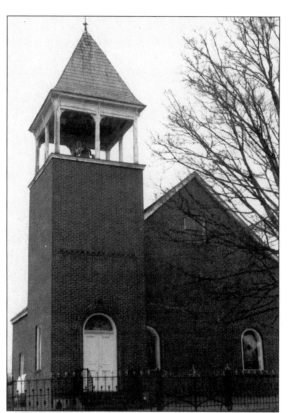

Tankerville Church (Bethel Lutheran) was built *c.* 1866, between Taylorstown and Lovettsville on the land that was originally granted to the Earl of Tankerville. The tower was added in 1903.

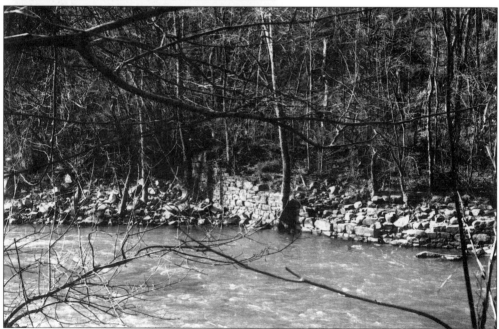

The Goose Creek canal was dammed up at several locations. This view shows the creek at Lee's Mill, near what was called the "Cotton Plantation." It is now owned by the Xerox company. (Photo courtesy of the John Lewis File at Balch Library.)

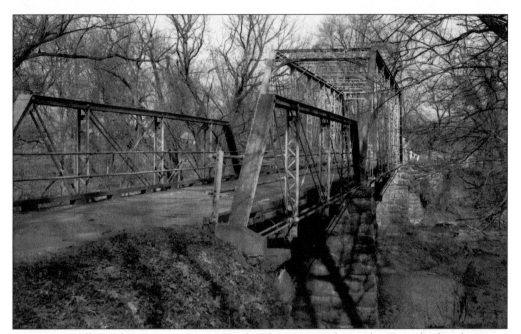

Evergreen Mill Road runs over Goose Creek. This picture shows the Truss bridge that once spanned the creek. A single-lane bridge, it was built in 1882 by the King Bridge Company of Cleveland, Ohio. In 1973, the Truss bridge was replaced by a modern concrete-and-steel, two-lane bridge. (Photo courtesy of the John Lewis File at Balch Library.)

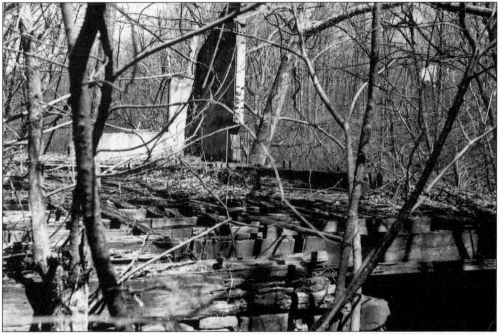

Goose Creek is a major waterway in Loudoun County. It has been used for transportation, food, mill products, and power to generate electricity. This photo shows the remains of the old Leesburg Light Company Generator Plant. (Photo courtesy of the John Lewis File at Balch Library.)

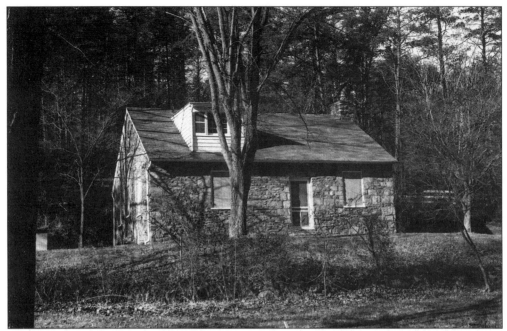

Coe's Mill was active in 1807. By 1871, the mill property spanned 5 acres and featured a mill and mill house. This view shows the house after it was re-built from the original mill's stone c. 1930. (Photo courtesy of the John Lewis File at Balch Library.)

Roach's Mill was originally owned by Richard Roach. The mill was constructed of native fieldstone. This view shows the ruins of the second house site on the mill property. (Photo courtesy of the John Lewis File at Balch Library.)

This is a view of the barn located near the site of Roach's Mill. (Photo courtesy of the John Lewis File at Balch Library.)

The Love House stands on property originally owned by the Earl of Tankerville and was probably built between 1760 and 1780. It is located near Purcellville and has been used continuously as a residence since it was built. (Photo courtesy of the John Lewis File at Balch Library.)

This home was built on an original land patent from Lord Fairfax to Francis Awbrey in 1731, and the original logwork shown in this view was built between 1820 and 1840. The house is presently used as a residence. (Photo courtesy of the John Lewis File at Balch Library.)

Janelia Farm was once part of two tracts of land owned by Thomas Lee, an agent for Lady Fairfax. It is located just outside of Ashburn. The manor house was built *c.* 1935 as the home of local and national artist Vinton Liddell Pickens.

Burr Ridge is an impressive estate located near Leesburg. The house is made of fieldstone and looks similar to Mount Vernon in design. It has a spectacular view of Virginia, West Virginia, and Maryland from its porches. It was once owned by Burr P. and Agnes Harrison. (Photo courtesy of the Winslow Williams Collection at Balch Library.)

Woodburn was acquired by George Nixon c. 1745. It was a large estate that had a manor house, mill, miller's cottage, several smaller buildings, a smokehouse, and a springhouse. Rudolph Nureyev called Woodburn home for several years. (Photo courtesy of the John Lewis File at Balch Library.)

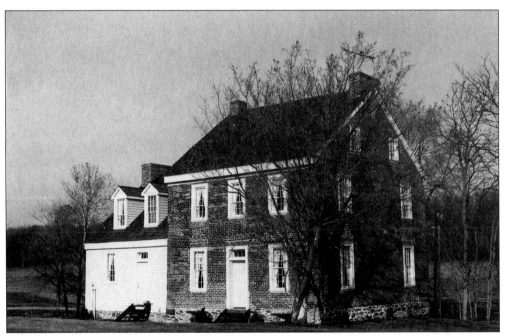

Weathering Heights was built in 1797. This property belonged to the Taylor family for generations. It was remodeled by Basil Delashmutt in the 1970s and has been a showcase home for the Lincoln area Dirt Roads Tour. (Photo courtesy of the John Lewis File at Balch Library.)

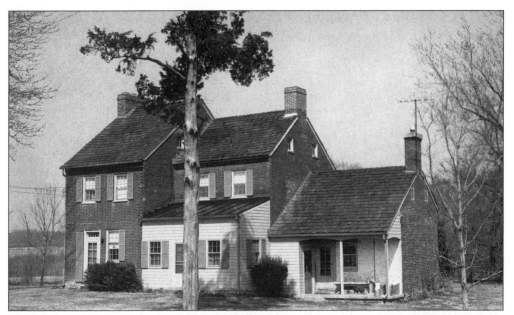

The Rocks was part of an original grant to Richard Brown consisting of 505 acres near Lincoln. It dates from the 1790s. The house has gone through several additions and renovations. (Photo courtesy of the John Lewis File at Balch Library.)

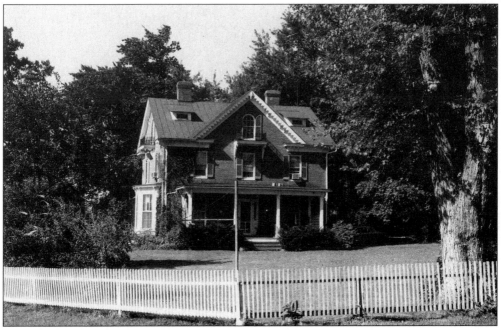

This house in Circleville is also part of the Brown Tract, and it remains in that family today. (Photo courtesy of the John Lewis File at Balch Library.)

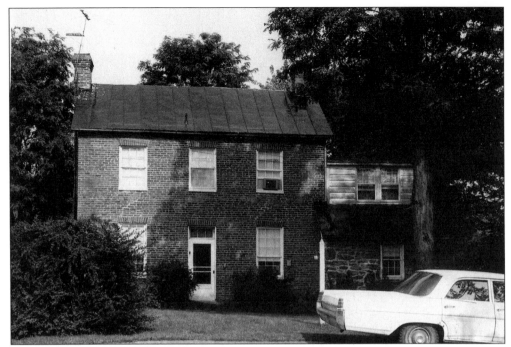

The Brown House at Circleville was built *c.* 1765. It has been in the Brown family since that time. Renovations and additions have been made, with the main section of the house remaining mostly untouched. (Photo courtesy of the John Lewis File at Balch Library.)

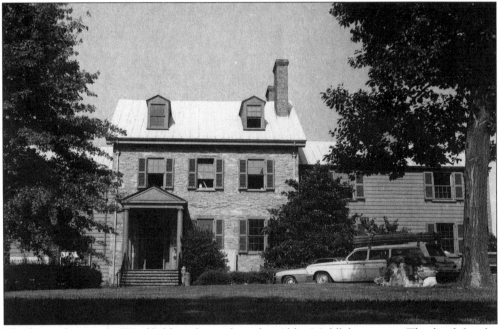

The house known as Windfields is located in the Aldie-Middleburg area. The land for the house was originally owned by Leven Luckett, and the house was built *c.* 1855. It was part of several large tracts of land that were part of the Hugh Quinland/George Fairfax Lee properties in the early 1800s. (Photo courtesy of the John Lewis File at Balch Library.)

This 1975 picture was taken by William E. Barrett. It shows the Arcola Mill in a state of disrepair. This mill was located behind the Arcola General Store.

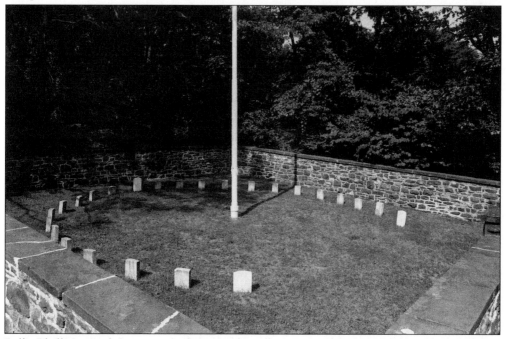

Ball's Bluff National Cemetery is the second smallest national cemetery in the United States, being less than 1 acre in size. It has 26 graves that memorialize those killed at the site in October 1861. It is maintained by the U.S. Government. (Photo courtesy of the John Lewis File at Balch Library.)

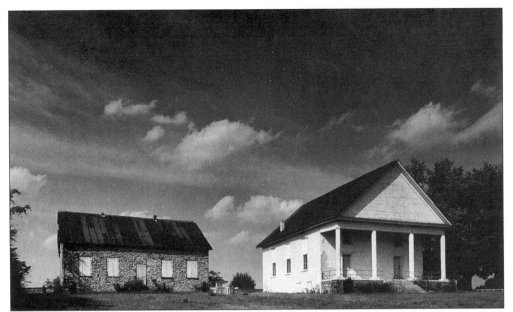

Seen in this William E. Barrett photograph, Old Ebenezer Baptist Church was built about 1760 on land owned by Samuel Butcher Sr. and since that time has been extensively restored. It is located near Bloomfield.

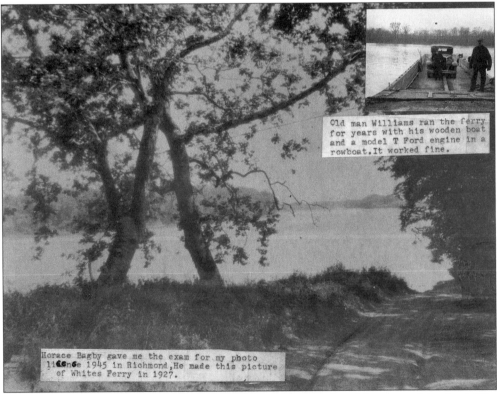

Old man Williams ran the ferry for years with his wooden boat and a model T Ford engine in a rowboat. It worked fine.

Horace Bagby gave me the exam for my photo license 1945 in Richmond. He made this picture of Whites Ferry in 1927.

White's Ferry continues to run daily over the Potomac River, from Virginia to Maryland. The *General Jubal Early* is the barge that carries 10–12 cars at a time.

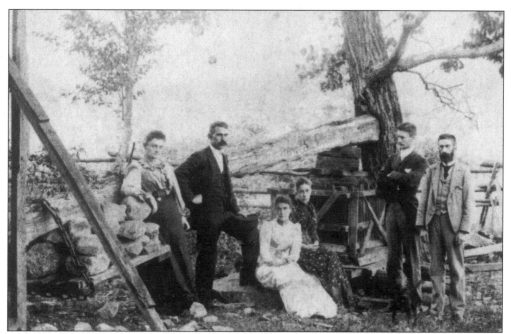

The Bates family is shown here at the Cider Press near Spring Grove c. 1885 in what is now Sterling, Virginia. (Photo courtesy of Balch Archives, from the photo album of Sabelle Bates Kirby.)

Lime Kiln is located on property that can be traced back to 1800. It was owned by Josiah Clapham. It was later called Chestnut Hill. The kiln was active well into the 1900s.

Bratton Hill was probably built by James McIlhany. The house was bought in 1796 by Joseph Tribby, and his family owned it until 1817. The house is now called Whitestone and has had several renovations over the past 100 years. (Photo courtesy of the John Lewis File at Balch Library.)

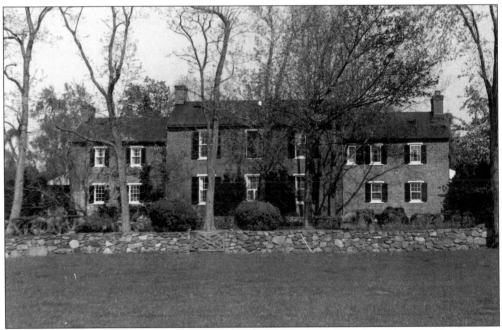

The historic home now called Hedgeland was built in 1820 on land first acquired c. 1750 by Col. James Hamilton, a member of the colonial House of Burgesses. Today, it is a well-known equestrian facility. (Photo courtesy of the John Lewis File at Balch Library.)

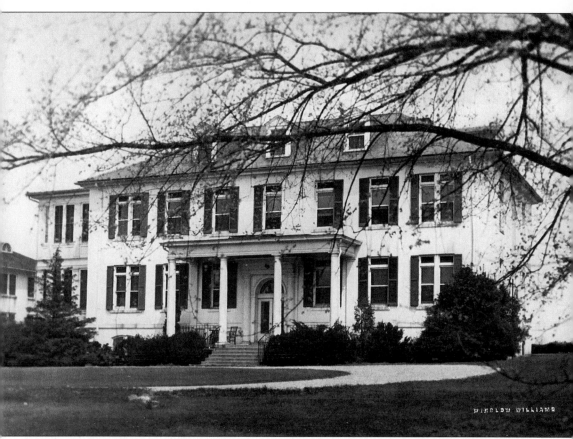

This is a 1946 photo of what is called the Old Loudoun Hospital, a teaching hospital for registered nurses. There was a garden for vegetables and flowers in the rear of this hospital. This Loudoun County hospital was used as part of a long-term care unit until the 1970s. Then in 1974, a new brick section was added, and this "wing" became an administrative and teaching wing. In 1997–98 the Loudoun Hospital moved about 10 miles farther east from Cornwall Street in Leesburg to a new, more modern facility in Lansdowne. This building with all its additions remains in use today. You can still walk up the steps and enter this building. The circle drive and lawn have long yielded to progress.

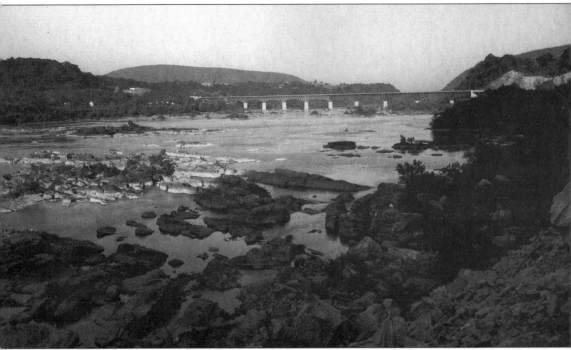

One of the scenic routes into Loudoun County from West Virginia is the Harper's Ferry Bridge. This photo was taken in October 1947 by Winslow Williams.

Loudoun County has been in a constant state of growth since the 1960s. The area of what is now Broad Run was mostly farmland and undeveloped. Bob Young, a lawyer, who lived in Leesburg is credited with starting the Broad Run Farm area subdivision—one of Loudoun's largest and fastest growing areas today. (Winslow Williams Collection, Balch Library.)

126

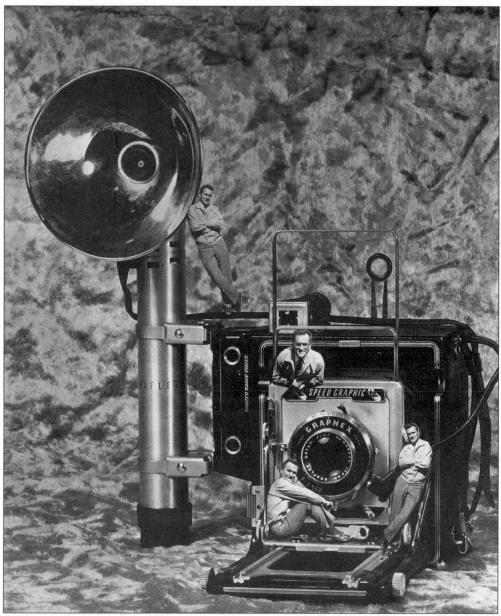

This book is dedicated to Winslow Williams, who was an avid photographer. For over 50 years, he took snapshots of Loudoun County. He owned and operated a studio in Leesburg for quite some time and worked as both a photographer for the coroner's office and the owner of Winslow Williams Realty Company. During World War II, he took strategic air command photos for the U.S. Government. His photographic collection was given to the Thomas Balch Library a few years before his death. Many of the photographs used in this book are copies of Winslow Williams's works. The Winslow Williams photo collection at Balch consists of over 7,000 photos and negatives of Loudoun County and vicinity. The above composite was a personal favorite of his. This camera was his prize possession. The author's undying gratitude goes to Winslow Williams, who has truly saved much of Loudoun County's history through the lens of his camera.

ACKNOWLEDGMENTS

My gratitude is extended to all those who helped to make this book possible.

Aldie Mill—The Virginia Outdoors Foundation; Steve Spring (Mill Photo)
Howard Allen—Allen Studios, Middleburg, Virginia
Phyllis Aurand—Photo Curator at Thomas Balch Library
Pete Gray—Round Hill Photos
Leesburg Pharmacy—Bruce Roberts and the photo department for copies and reprints
Theresa Perkinson—Great job on editorial work
Helen Hammerly Shedd—Round Hill Photos
Jane Sullivan—Thomas Balch Library Manager
Ann Whitehead Thomas—Round Hill Photos and Historical Consulting
Waterford Foundation, Inc.—Waterford Photos and History

Special thanks to the staff at Balch Library for their use of the following:
 Eugene Scheel's Historical Collection on Towns and Villages
 John Lewis File on Old Homes (Virginia Landmarks Commission Papers)
 Winslow Williams Photo Collection

My extended thanks go to the Town of Leesburg, whose acts of farsightedness have allowed the Thomas Balch Library to function as a premiere history and genealogical library in Leesburg, Virginia.